DORSET

PUBS AND BREWERIES

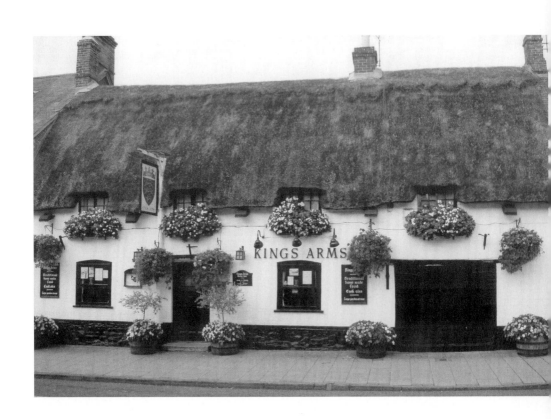

Christmas 2010.

I love our week-end escapes in

DORSET

PUBS AND BREWERIES

Honey

TIM EDGELL

AMBERLEY

For Sarah, Hope and Isabella, Mum and Dad.

Charity Donation
For every book sold, the author will make a donation to cancer charities

Frontispiece: Ere's greetens vrom Darzet. The Kings Arms at Wareham – a rejuvenated classic – has all the elements of an outstanding pub. Good looks, good beer, good atmosphere and, of course, all-day breakfasts.

First published 2009

Amberley Publishing Plc
Cirencester Road, Chalford,
Stroud, Gloucestershire, GL6 8PE

www.amberley-books.com

Copyright © Tim Edgell 2009

The right of Tim Edgell to be identified as the Author of this work has been asserted in accordance with the Copyrights, Designs and Patents Act 1988.

ISBN 978 1 84868 203 0

British Library Cataloguing in Publication Data.
A catalogue record for this book is available from the British Library.

Typeset in 10pt on 12pt Sabon.
Typesetting and Origination by FONTHILLDESIGN.
Printed in the UK.

Contents

Acknowledgements

Extra special thanks go to Hugh and Sue Elmes.

Special thanks to Annie Blick, Mike Bone, English Heritage NMR, Andy Lane, Ian Mackey, Keith Osborne.

Many thanks to Rachael Aplin, Trevor Armitage, Bob and Gill Baker, Julia Ballard, Kelvin Barry, Ann Basford, Baz (Dorchester), Jonny Billington, Blandford Forum Museum, Steve Bowles, Lynda Broadhead, Alan Brown, Michael and Mary Conkling, Paul Conway, Freddy Cook, Peter Cove, Roger Davis, Glen Del Medico, Peter Dodd, Dorset History Centre, Jon Edgson, Dr Graham Elmes, Ray Farleigh, Christopher Fookes, Hilda Fripp, Gary (Shipton Gorge), Gabriel Gaylard, Paul Harris, Charlie Hathaway, Andrew Hawkes, Mike and Margaret Hawkes, David Haysom (Swanage Museum), Margaret Hearing, Daveen Hermer, Michael Hooper-Immins, Mark Howlett, Len Keys, John King, Val Lamb, Michael Le Bas, Pippa Lightbown (Isle of Purbeck Brewery), Richard Lilley, Rob Martin (Dorset Piddle Brewery), Stuart Morris, Russell Murfitt, Charles Nodder, Gerald Notley, Cleeves Palmer (Palmers Brewery), Bernard Paull, Rick Payne (Hall and Woodhouse), Mike Peterson, Poole Local History Centre, Brian Roper, Sherborne Museum, Giles Smeath (Dorset Brewing Company), Paul Smith (Small Paul's Brewery), Jim Stace, Hamish Summers (Isle of Purbeck Brewery), Andrew Swift, David and Wyndna Taylor, Mike Thornton (Dorset Brewing Company), David Tuffin, Steve Walsh (Sherborne Brewery), David Watkins, Steven Welsh, John and Becky Whinnerah (Art Brew), Kevan Witt.

And to everyone else who has given me help, information and encouragement.

Andy Lane actively collects brewery and pub memorabilia from Dorset breweries. He can be contacted on 07789 275242.

Introduction

The author's journey began long ago with wonderful family holidays in Swanage in the early 1970s and being allowed a half of shandy at the Square & Compass at Worth Matravers, the Scott Arms at Kingston, and even the Smiths Arms at Godmanstone.

Then followed research into family history and the discovery of the grave of my great-great-uncle Henry Edgell in Swanage Churchyard. One day, while sitting at the Crown in Fontmell Magna and looking at the old brewery, questions came to mind. In which pubs did Henry drink and which beers did he drink in them?

Since then, the author has visited most pubs in Dorset and all eight of the breweries currently brewing wonderful Dorset ale.

The book concerns itself with 'old' Dorset – the county before the 1974 boundary changes, so apologies to Bournemouth and Christchurch.

Contrary to most other pub and brewery publications, which follow an alphabetical approach, the author has chosen an area-based format. The book follows swaggering footsteps with a zig-zag order. Each chapter takes an area and moves from east to west in sweeps, before moving northwards to start another. It is a bit like an old typewriter in reverse.

In going for this approach, the author hopes to prompt visits to hostelries close by, as well as making suggestions for trips further afield. The main aim is to create a thirst, not only physically to encourage a pub visit and to drink beer from a local brewery, but also for a bit of knowledge and history.

The author's first recollection of a pub is a dingy local in the 1960s. It was smoke-filled, working-man dominated and dingy. In fact, so dingy that the memories are in black and white. How pubs have changed.

Now, most pubs are food-led, as 'wet' sales have decreased. Pubs are increasingly visited by families and women. The smoking ban has changed the social mix in pubs. Hard wooden chairs have disappeared in favour of padded seats for padded bottoms.

Most people still go to the pub for the company and atmosphere. It is increasingly rare to find a pub with a 'personality landlord' as the demands of running a pub increase and more are managed. However, there is a danger of confusing tradition with merit. There has to be a balance between progress and preservation, but life is not perfect. Community pubs are cherished, good pubs receive recognition, and world class, timeless classics thrive.

Historically, there have been four main Dorset breweries: Hall and Woodhouse at Blandford Forum, Devenish & Groves at Weymouth, Eldridge Pope at Dorchester and Palmers at Bridport. All have their own books and publications, so the author has limited the space given to them to match that given to the lesser known closed breweries and current micro-breweries (who need the exposure and support).

These are contradictory times for the brewing industry. Nationally forty pubs are closing each week. National brand sales are decreasing by as much as 10% year on year. However, most savvy regional and micro breweries have bucked the recession and have seen an increase in sales. This is probably due to a number of reasons. There is a much greater awareness of 'food miles' and 'carbon footprints' so drinkers are looking for more locally sourced beverages. There is evidence of a resistance to advertisement-led brands. CAMRA initiatives such as 'Locale' (local ale) and National Pubs Week all help to inform the public.

The national brands are increasingly bland and of a uniform taste, so the opportunity for a large brewer to experiment is more limited. Compare this outlook to Hall and Woodhouses' excellent range of seasonal ales. The quality and consistency of micro brewery beers have also improved.

Dorset is without doubt a classic county. It has no motorways and is a web of rural villages and market towns. The coastline is stunning, with varied and iconic features. It has a smuggling past and, more recently, a naval history.
The pubs reflect this history and diversity. There are coastal inns, rural beer houses, town coaching inns and large Victorian set pieces. However, in the last twenty years, Dorset has lost up to 20% of its pubs.

Thankfully, Dorset's losses have slowed. The naming of the Jurassic Coast, and its designation as a World Heritage Site in 2001 have raised Dorset's profile world-wide and tourists have flooded in. However, locally, some communities have been left high and dry. Halstock and Morcomblake are both left without a pub, although a golf club at the former has done its bit to fill the space.

As to the future, there will be increased pressure on pubs. The 'Pub is the Hub' initiative supported by Prince Charles has stalled somewhat. Putting post offices into pubs is a good idea, but the future for the post office network itself is in the balance. Government-imposed restrictions, such as a minimum price per unit of alcohol or a reduced glass size are on hold at present.

People are trying to fight back. CAMRA backed an 'Axe the Beer Tax' campaign and lodged a 'Super Complaint' with the Office of Fair Trading against the alleged practices of Pubcos. In a recent article, Nicholas Oldcroft, Landlord of the Angel in Poole, said that a 20% increase in real ale sales had been wiped out by a 20% increase in beer tax.

Beer sales are hit by supermarket discounts. However, Dorset breweries have responded to the increased drink-at-home trade. Hall and Woodhouse, Palmers, the Dorset Brewing Company, the Dorset Piddle Brewery and the Isle of Purbeck Brewery all offer a varied range of bottled beer.

To sum up, a book like this cannot list every pub and brewery in Dorset. So, apologies if your favourite is not included. Apologies to some great pubs not included such as the True Lovers Knot at Tarrant Keyneston, the Trooper Inn at Stourton Caundle, the Manor Hotel at West Bexington and the Fox Inn at Corscombe. There are many, many more too.

Perhaps the book should come with a politically correct disclaimer: 'in the interests of balance, other pubs and breweries are/were available'.

Finally, please visit a Dorset pub and buy a Dorset beer.

Poole and Wimborne to Cranborne

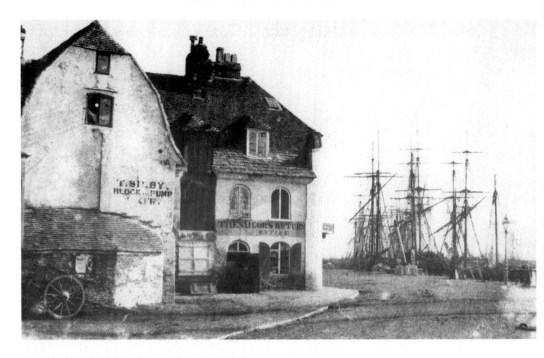

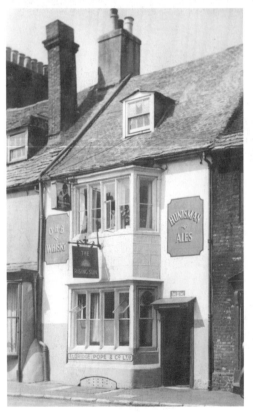

Above: Back in 1854, the Sailor's Return (closed *c* .1936) sold 'Entire', a porter style beer combining elements of old, brown & pale ales. The tall ships have been replaced by fabulous Sunseeker motor yachts whose crews seek out the pubs on the Quay such as the Lord Nelson, Poole Arms and Portsmouth Hoy.

Left: The Rising Sun was in Castle Street, surrounded by medieval and Georgian buildings built by wealthy merchants. It had been one of Poole's leading inns and was owned by Styring & Co, Poole Brewery. However Poole Borough Council initiated extensive demolition of the area in the late 1950s and the once fabled inn is no more.

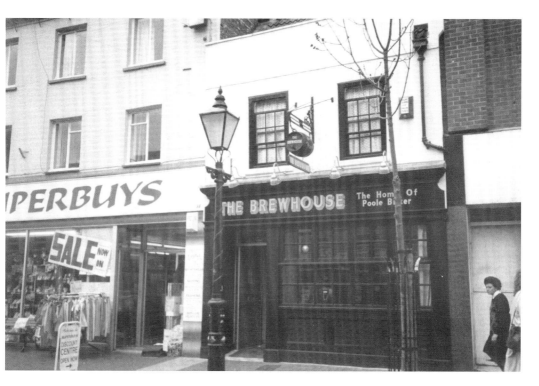

Above: David Rawlings founded the Brewhouse in 1983 in Poole High Street. Initially mainly Purbeck lager was brewed in summer and occasionally in winter. In 2002 the pub was sold to the Milk Street Brewery of Frome, Somerset, who continue to run a lively house with an excellent range of their beers including Funky Monkey and Mermaid.

Right: Poole Brewery was started by David Rawlings, prior to the Brewhouse, in 1981. Brewing was transferred to the Brewhouse site in 1990. Beers such as Best, Bedrock and Bosun bitters were sold through the pub and also to thirty-five free trade outlets. There were commemorative bottlings e.g. Royal Wedding Ale (1981). The brewery closed in 2002.

Poole Brewery.

TELEPHONE No. 11

STYRING & CO.

POOLE · DORSET

STYRING & CO.,

Brewers & Importers of Wines & Spirits,

GOLDING HOP ALE,

AND

NOURISHING STOUT,

IN SCREW-STOPPERED IMPERIAL PINTS. at 2s. 6d. ¡ r Doz.

TO BE OBTAINED FROM

TELEPHONE No. 101.
Mr. W. HUMPHRY, Lansdowne Cellars, Bournemouth.

TELEPHONE No. 93.
Mr. L. JOHNSON, Commercial Road, Bournemouth.

TELEPHONE No. 67.
Messrs. WILLIAMSON & SON, Arcade Stores, Bournemouth.

Left: Styring & Co, Poole Brewery advertised 'Golding Hop Ale – light, pure and invigorating in pints for 2/6 per dozen'. The brewery was founded by J. King in 1795 and by 1818 was in Towngate Street. Sold to Frederick Styring and Martin Welch in 1852, it was bought by George Pope in 1880 (still trading as Styring & Co) and then Eldridge Pope in 1900 with thirty-four pubs.

Below: The Swan first appeared in 1607 and the surviving premises were built next to the original in the early twentieth century. Adorning the Swan is a highly decorative glazed brick and tiled façade almost certainly supplied by Poole firm Carters. After years of being boarded up, the building reopened in 2009 as the Ginger Pop Shop.

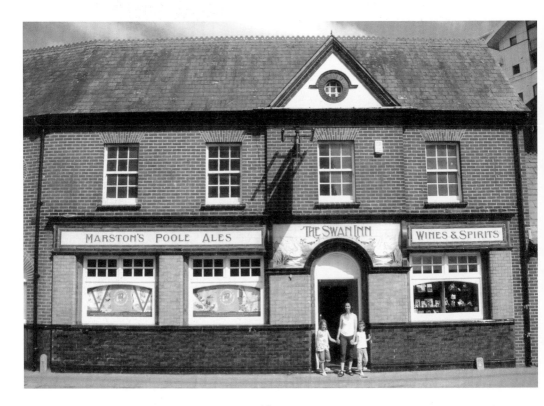

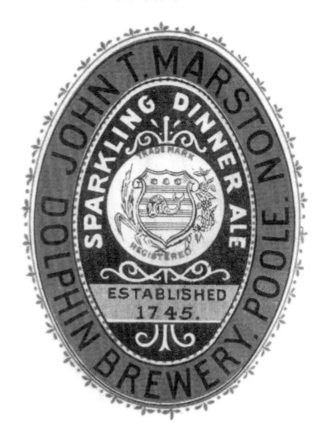

Established in 1745, the Dolphin Brewery began in a shed next to the Dolphin Inn. It had various owners including Amey, Rickman, and Emmott, until solely owned by John Marston in the 1870s. The Antelope and its brewery were acquired in 1870. In Market Street, the Dolphin Brewery and Georgian offices with 58 pubs were acquired by Strongs in 1926. The brewery was demolished in 1974.

Ghostly goings-on abound at the Crown Hotel, especially after an old stable was turned into a disco in the 1960s. Phantom piano players, spooky unlocking doors and wailing children in empty rooms have all been reported. On the other side of Market Street is the Angel, where saintly landlord Nicholas Oldcroft offers a heavenly range of ales.

The recent CAMRA award-winning Brankstome Railway Hotel deserves all its plaudits. Built in 1894, in typically distinctive late Victorian style, it retains many original features such as the heavy woodwork and high ceilings. These large showpiece town pubs are under threat (the Tatnam nearby has just been boarded up) so they need support.

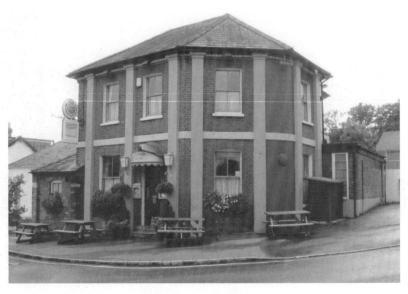

Twenty years ago, the Bull's Head in Parr Street, Parkstone (previously a Pantons of Wareham then Strongs house) became the Bermuda Triangle. With landlady Gisela Crane directing operations, the award-winning pub is a magnet for real ale drinkers. As the Bricklayers Arms, the Central and the Britannia are nearby, this part of Parkstone should be savoured.

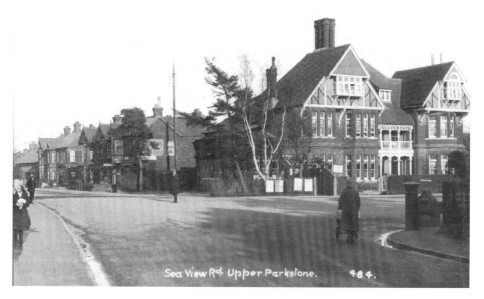

From the 'Huntsman' 1974 (Eldridge Pope magazine) 'Customers just give their orders for 'cheese', 'tomato', 'mushroom', 'ham' or even 'Spanish' or 'Italian', Mrs Cook (landlady) says that Constitution Hill has not been the same since the omelette craze started'. Perhaps fortified by omelettes, the Bryant brothers were frequent winners of the annual Boxing Day Pram Race run from the Sea View Hotel, Parkstone.

The present Willett Arms in Canford Magna dates from the 1930s and describes itself as a 'cracking village pub restaurant with local brews and guest ales too'. It was named after either the land-owning Willett family or William Willett MP who introduced 'summer-time' which came into practice in 1916. We have him to thank for longer summer evenings in the beer garden.

15

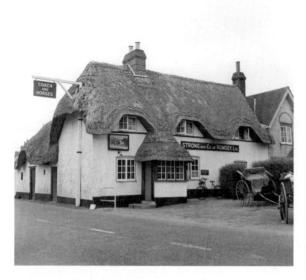

A short distance south of Wimborne on the Poole Road, the Coach & Horses remains a traditional pub. Originally a fifteenth-century cottage, it has a flagstone floor and inglenook fireplace. Beers are well kept and older drinkers will remember the sign on the outside gents' loo 'Yer tiz'.

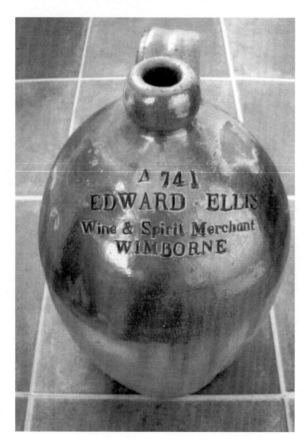

The Town Brewery was founded by Charles & Edward Ellis in the mid 1820's at Mill Lane to the east of The Square. In 1915, Ellis Brewery acquired several of Habgoods Julian Brewery pubs and was in turn sold to Hall & Woodhouse in 1937 with 18 pubs. There are still some traces of the brewery, next to Ellis's house.

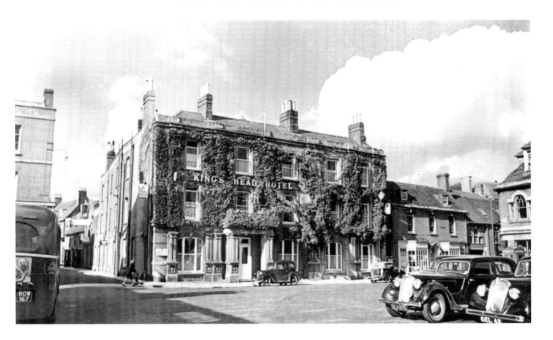

Above: The 200 year old King's Head Hotel in The Square is owned by Greene King. Known as the Laings Hotel in the nineteenth century, an extra storey was added in *c.* 1885 and it is now a very refined venue. Across The Square, the Albion (Wimborne's oldest inn) was gutted by fire on 4 July 2009. Total restoration will be needed.

Right: A quaint seventeenth-century pub in the Corn Market, the White Hart is highly regarded by locals and visitors alike. In times past, the parish beadle would handcuff offenders to an iron bar while they waited for the stocks outside. The George was nearby (nineteenth century homebrew inn) while the Oddfellows Arms and Green Man survive and are worth visiting.

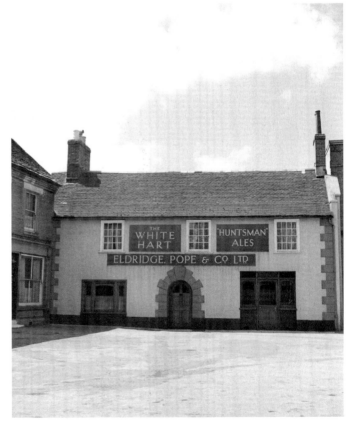

Left: Behind the Three Lions Hotel, then owned by Groves of Weymouth, was the Julian Brewery built by George Habgood in 1876. Previously Joseph Piddle had brewed at the inn. The Julian Brewery was sold to John Groves in 1915 and the pub estate split between Groves and Ellis. Now called the Pudding & Pye, the whitewashed three lions are still above the porch.

Below: Beer is served by gravity at the Coventry Arms, Corfe Mullen, just as it has been for centuries. Superbly preserved, this is a superior hostelry. Paranormal activity is denied and certainly witches are kept at bay by the 500 year old mummified cat found nailed to one of the rafters.

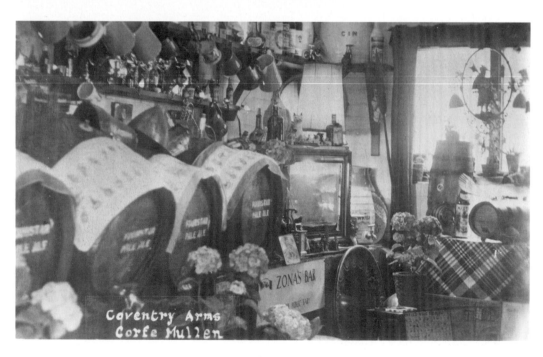

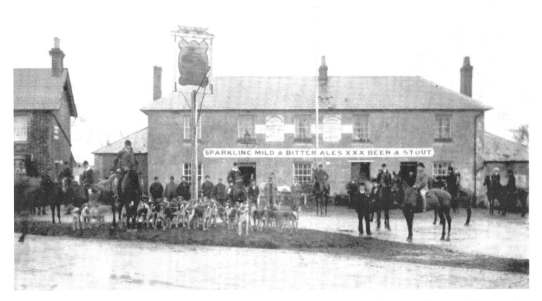

Although much older, the super St Peters Finger at Lytchett Minster has been a Hall & Woodhouse pub for over a century and has been renovated in traditional style. Its name is most likely a Dorset corruption of the Latin St Peter 'Ad Vincula' – the image of St Peter being released from chains by angels.

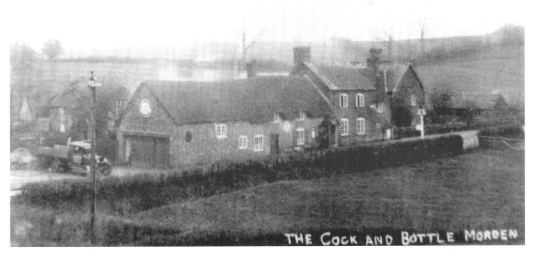

The award winning Cock & Bottle at East Morden is a classic, old-style, well run village pub. Rooms follow on from one another and there is a handsome public bar. In part 400 years old, and an inn since 1859, the name refers to both draught and bottled beer on sale. The 'cock' is a spigot which when removed allows ale to flow.

Situated at the other end of Long Lane to the Horns Inn, is the Barley Mow at Colehill. Once there, the 400 year old Hall & Woodhouse inn, with wood panelling and beams, is a wonderful find. Nearby too is God's Blessing Green, where Cromwell's troops were blessed before attacking Corfe Castle.

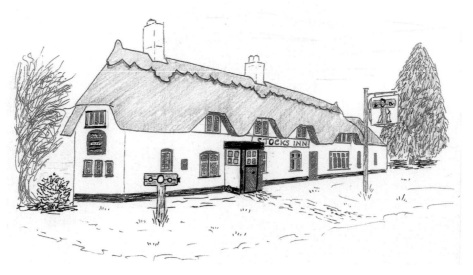

With connections to the infamous smuggler Isaac Gulliver, the Stocks Inn at Furzehill was used as a contraband distribution point. There are two floors of cellars and a lost underground passage to nearby Smugglers Lane. It is an archetypal Dorset pub – whitewashed walls, thatch and great beer. There are old stocks inside and out. And it is haunted too.

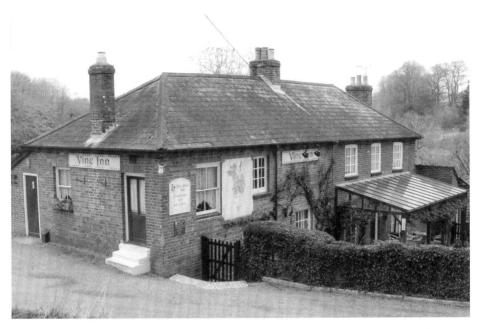

The Vine at Pamphill was licensed around 1900 and has become a Dorset gem. Still in the same family, it was run by Eli Ricketts until 1946, by Owen Ricketts till 1984 and now by Linda. Firstly tied to Marstons of Poole, then Strongs then Whitbread, it is now a free house. Wonderfully unspoilt, it also has its own cycle club.

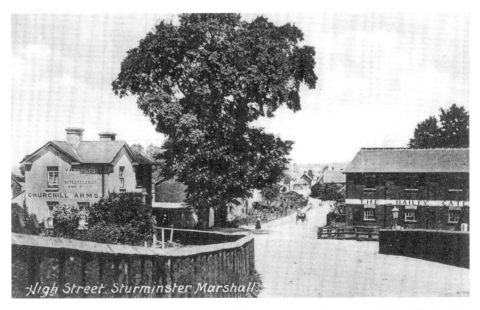

In Sturminster Newton High Street, the Churchill Arms advertised 'Marstons' Noted Poole Ales & Stout' – such as Mild, Old, Extra Brown or East India Pale Ale. Today it is an appealing community local and is complemented by the charming Red Lion opposite the Church and the equine paraphernalia adorned Black Horse on the Blandford Road.

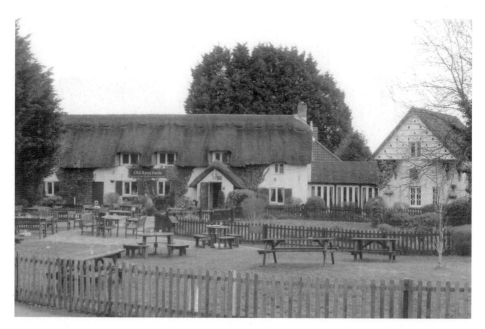

To the east of Three Legged Cross, lies a wonderful building that in 1986 became the Old Barn Farm pub. Going back, it was part of Lord Normanton's Estate – the land and buildings were sold in 1919 for less than £1 an acre. Part of the Vintage Inns chain, it is ideal for families.

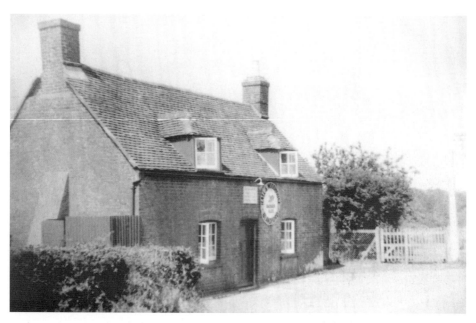

Four centuries ago, travelling monks from Wimborne built resting houses along their routes. Most have gone but one has become the Cross Keys at Mannington. The original walls have been bricked up but a welcoming inglenook fireplace survives. It is in an isolated position but, like the monks, you'll be glad when you get there.

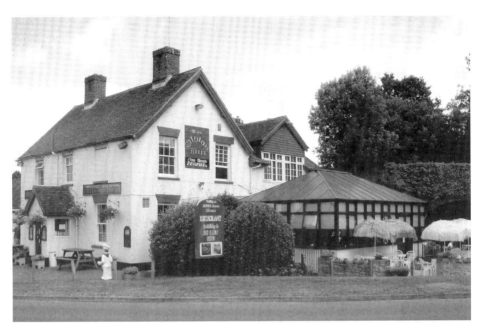

The Albion Hotel used to be trackside at Verwood Station. An old railway bridge is still there too and is partially visible to the right. At the turn of the twentieth century, the Albion was one of two pubs in Dorset owned by Gibbs Mew of Salisbury. The other was the White Hart (now Dolphin) at Blandford Forum.

In Daggons Road, west of Alderholt, the Hall & Woodhouse owned Churchill Arms keeps the flag flying for quality ales in the north east corner of Dorset. Indeed, there are letters of praise from the brewery for cellar keeping and front of house excellence. The recent extension at the rear has added to the Churchill Arms' appeal.

The Fleur de Lys at Cranborne (right) is a superb Hall & Woodhouse pub. An inn by the seventeenth century, the fabric incorporates old features from monastic ruins. Ale was certainly brewed there – William Tuck advertised as brewer and victualler around 1880. Sadly William Brook was too late for Fleur de Lys ale when he wrote of 'fine hoppy ale and red firelight'

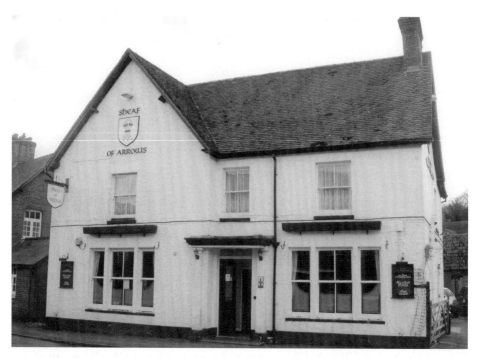

In the Square, the Sheaf of Arrows remains a warm welcoming local. At the rear, a small brick built stable with visitors gallery was home to the short-lived Cranborne Brewery. The pub unfortunately sold Cranborne Ales for only two years, but now has ales from the Dorset Piddle Brewery.

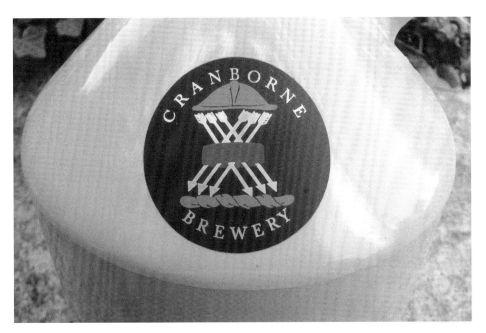

Established in February 1996 by John & Kate Tuppen with help from Graham Moss, the Cranborne Brewery was opened by Lord Cranborne (Leader of the House of Lords). They first brewed on 12/03/1996, to a secret recipe. Other brews followed such as 'Quarrel', 'Quiver' and 'Cranborne Ginger Beer' but, after a change of ownership, the brewery closed in 1998.

Close to Wimborne St Giles, the Bull Inn lies at the centre of the Shaftesbury Estate, whose family shield has three bulls – hence the pub's name. A traditional rural inn, the locals have signed a 'Bring Back Bulli' petition to return a small bull statue that disappeared a while ago. Stourvale Mummers perform every Christmas – long may this continue.

A marvellous country hostelry with a sumptuous menu, the Museum Inn at Farnham is a class apart. It flourished when Augustus Henry Lane Fox Pitt Rivers developed his personal museum of archaeological and ethnic objects at Farnham in the late nineteenth century. Now, after sympathetic restoration, the inn flourishes again. All this, and local guest ales on rotation.

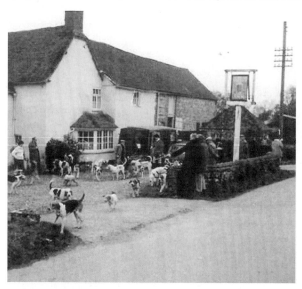

Outside the Hop & Barleycorn at Deanland, the Wilton Hunt gathered with landlord Sidney Perrett. Hall & Woodhouse bought the old pub in 1911, but in 1977 it shut for the last time. Long ago, locals gathered around the first radio in the area and listened to a concert from London. When over, they sang a Dorset song into the radio back to the orchestra.

two

Purbeck to Bere Regis

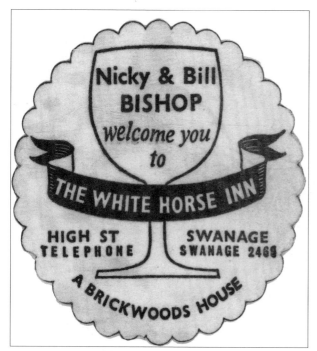

Left: At the southern end of Swanage High Street, the White Horse was a rare Dorset outpost for the Portsmouth brewer Brickwoods. Until the brewery was acquired by Whitbread in 1971, Brickwoods had only two other pubs in 'old' Dorset – the Smugglers Haunt at Ferndown and the Old Thatch near Wimborne. The drip mat comes with authentic Brickwoods' beer stains.

Below: In the Square, the White Swan lately advertises beers from the excellent Dorset Piddle Brewery. In the 1930s the pub drew attention to itself by different means – Polly the Parrot. She spent most of her time outside and raised money for the hospital. After moving to the Greyhound at Corfe, she sadly became an ex-parrot, when killed by a dog.

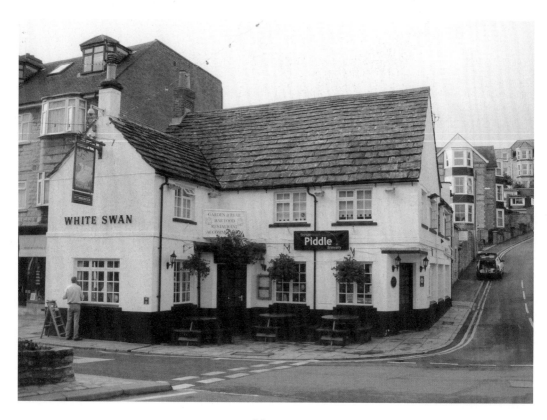

James & Henry Panton, brewers from Wareham, leased the Swanage brewery in Ingrams Mead in 1843 from P Talbot. Rebuilt after a fire in 1854, it was bought by Strongs of Romsey in 1893, demolished in 1899 and the Health Centre now occupies the site. Swanage Pale Ale was claimed to rival Burton beers on account of brewing water quality.

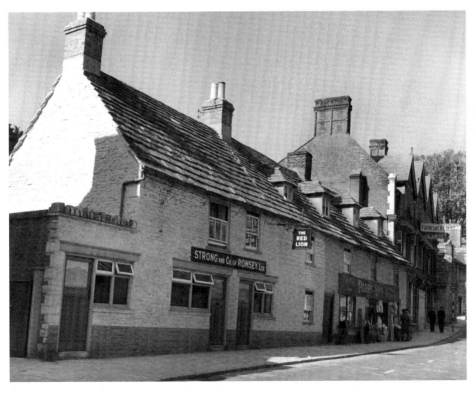

Further up the High Street, is the CAMRA award-winning and Good Beer Guide regular – the Red Lion. A seventeenth century survivor, it was previously three cottages, and is resplendent with brilliant cut and etched Strongs Brewery windows. The Red Lion is an eager supporter of local breweries an offers and extensive range of ciders.

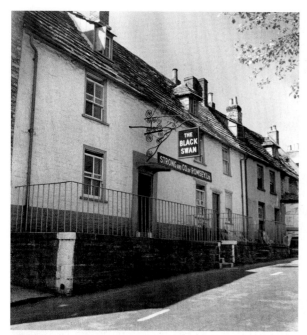

Left: From fairly humble beginnings as a quarryman's inn, the Black Swan now prides itself on being a 'cultural oasis'. Current research suggests it is the oldest pub in Swanage and it was used as a coaching inn and staging post for the Royal Mail. The railed-off platform at the front for stacking stone 'pennies' is the last surviving example.

Below: The Globe Inn at Herston was named after John Mowlem's forty ton Purbeck stone sphere that sits at Durlston Head. Previously, the inn was called the Anchor and was a safe house for men avoiding the Press Gangs. The Bower family kept the Globe for most of the twentieth century and many original features remain.

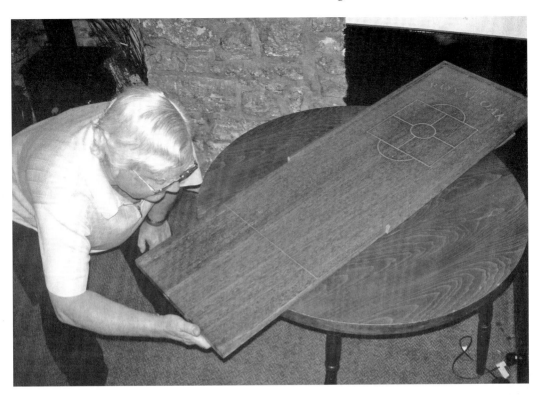

Above: Len Keys expertly shoves a halfpenny on a Purbeck longboard at the Royal Oak at Herston. Usually made of mahogany, the Royal Oak board was fashioned from a fire station bench. Current landlady Rachael Aplin was foretold years ago she would have the Royal Oak, which she has built up into a cherished traditional 'local'.

Right: This specialised version of shove-halfpenny is confined to the Isle of Purbeck. The longboards are about five feet in length and have scoring areas as shown. The game dates back to Tudor times and 16 pub teams still battle it out in two leagues. The '20' bed encourages an attacking game. First to 101 wins.

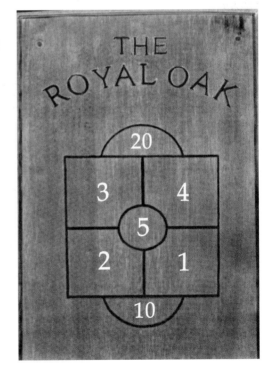

At Studland 120 years ago, the New Inn was rebuilt and then renamed the Bankes Arms. The landlord in 1906 was Richard Clark (late of the Ship Hotel Swanage) who offered 'lobster and prawn teas'. Since 1988, the Lightbown family have run this superb hostelry, now with its own microbrewery. A 'momentous' beer festival is held annually in the gardens opposite.

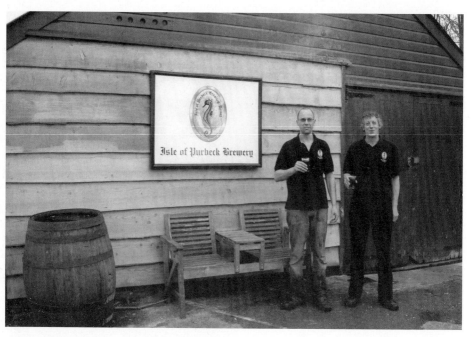

Assistant brewers Jonny Billington and Hamish Summers stand outside the Isle of Purbeck brewery with a welcome beer in hand. The brewery was established by Jack Lightbown and Hamish in 2002, in outbuildings next to the Bankes Arms Hotel, named after a local family. The ten barrel plant is from the Brewhouse Brewery in Poole.

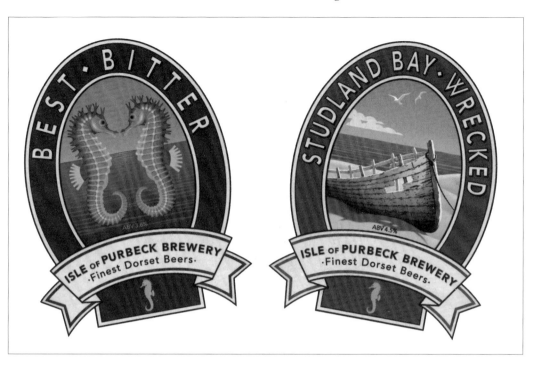

Above: The current range is Best Bitter, Fossil Fuel, Solar Power, Studland Bay Wrecked, Purbeck IPA and Thermal Cheer (winter seasonal). Beer quality is consistently good and the range has just been rebranded using classic local images. Increasingly the beers are available away from Studland but, handily, most are available next door, or in bottles.

The old Ship at Langton Matravers, first licensed in 1765, was in a farm workers cottage. After the unfortunate suicide of the landlord John Ball on 18 December 1878, it became unpopular and the new Ship was built to the left in 1884. Tastefully refurbished and retaining artefacts set into the walls, it sells ales supplied by the Isle of Purbeck brewery.

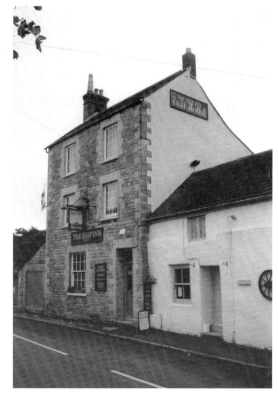

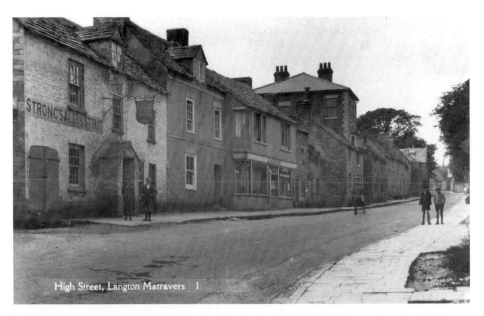

High Street, Langton Matravers 1

Dating back to the 1600s, the Kings Arms was previously called the Masons Arms and the Mallet, referring to the very local quarries. At one time a homebrew pub, it was also a smugglers' haunt for many years. Further along the road was a small brewery from where the Edmunds family supplied beer in the latter half of the nineteenth century.

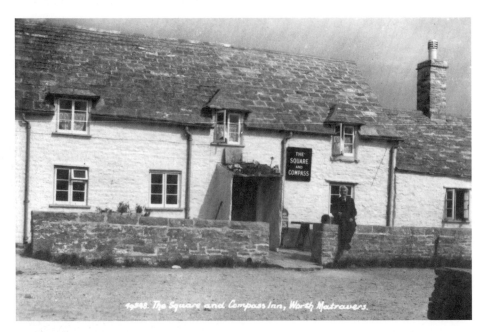

A veritable classic, the Square & Compass at Worth Matravers has its own book of 156 pages, is in CAMRA's National Inventory of Heritage Pubs and is one of the 'Perfect Nine' pubs nationally to have been in all 37 editions of CAMRA's Good Beer Guide. Enough said.

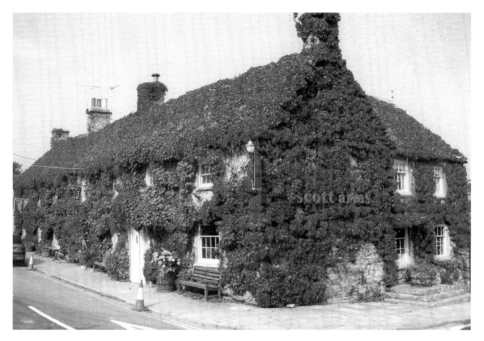

The Scott Arms at Kingston is a fiery creeper clad beacon for several weeks each year, but is always well worth a visit. Autographed photos of local location filming hang on the walls. The minstrels' gallery from which folk music was played is now home to a brown leather sofa. The view (giving nothing away) is world class.

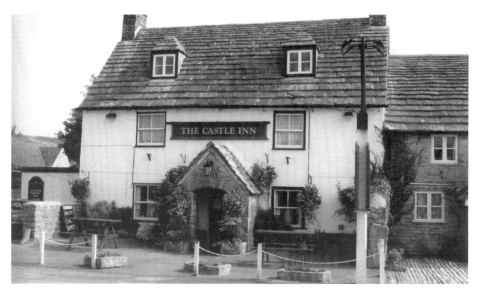

Away from the centre of Corfe, the Castle Inn is well worth visiting A resident ghost called Ethel haunts the 300 year old inn and does not like workmen near the fireplace. In the nineteenth century, beer was brewed in the cottage next door which was later sold by Whitbreads. The gardens to the rear overlook the Swanage Steam Railway.

Peeping out from under the creeper on the right is the ancient Fox Inn. Formerly a Pantons Brewery house, it was a homebrew inn centuries ago using water from a well which is now preserved within the pub. The Fox is a real gem and has been run by the same family for several generations. Although the bar is small, the beers are good.

With the ruins of Corfe Castle at the end of the garden and, like most of Corfe, probably made from some of its stone, the Greyhound is a fine old inn. Reputedly a home brew pub up to 1889, it now hosts two beer festivals annually. With the Bankes Arms opposite, there are four great pubs to visit at Corfe Castle.

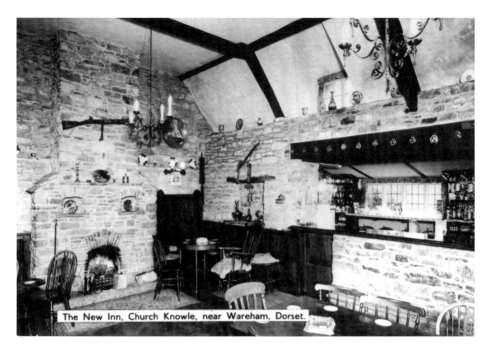

The New Inn, Church Knowle, near Wareham, Dorset.

Not so long ago, most country inns had fairly basic interiors but with changing clientele, things have altered for the greater comfort of guests. However the New Inn, run by the Estop family for over twenty years, is not so different today and well rewards the few mile trip from Corfe Castle.

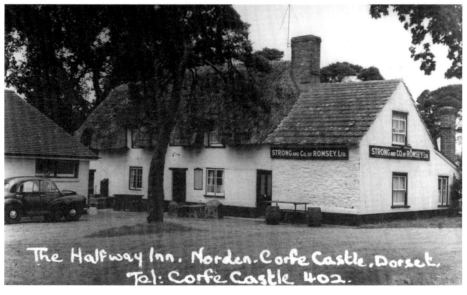

The Halfway Inn. Norden. Corfe Castle, Dorset.
Tel: Corfe Castle 402.

Located in an isolated position between Corfe and Wareham, the Halfway was probably the exchange point for mail services between the two towns. Certainly it was a clay miners' inn for centuries. Nearby, the Blue Pool at Furzebrook is the result of a disused opencast mine. The Halfway is currently a Hall & Woodhouse pub.

Left: In 1642, Cromwell's troops were supposedly billeted at the now Kings Arms at Stoborough. The name would certainly have been different then! The original building probably did not survive 1643 when much of Stoborough was demolished to stop the Royalists using it for cover. Today it is a fine pub selling local ales.

Below: A group of likely lads on a Royal Blue Charabanc (from Elliott Bros of Bournemouth) stop outside the New Inn on the Quay, Wareham. Pre 1926, it was owned by Marston's Dolphin Brewery of Poole. In 1934, landlord Gordon Sansom started the Muddlecombe Men – a troop of comedy performers who still raise funds for charity. More recently the pub was renamed the Quay Inn.

On Abbots Quay (centre right) was Bennetts Brewery. Previously the brewer was Stephen White. A 1900 survey listed the brewery, stabling for 5 horses and malthouse, which still stands. The brewery was sold to Strongs in 1906 with eleven pubs including, in Wareham, the Lord Nelson, Horse & Groom, Duke of Wellington and Pure Drop.

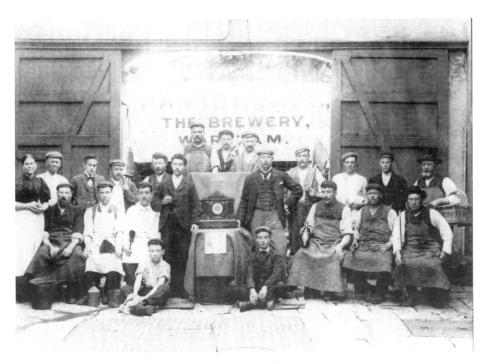

Wareham's other main brewery was Pantons in Pound Lane. Established in 1818 by the Phippard family, it passed to Samuel Townsend in 1821. James & Henry Panton, who were brewing at Saw Pits, took over in 1843 (and also the Swanage Brewery). In 1870, they acquired Veals of Ringwood but sold up to Strongs in 1892 with forty-six pubs. Fifteen pubs in Southampton went to Scrases.

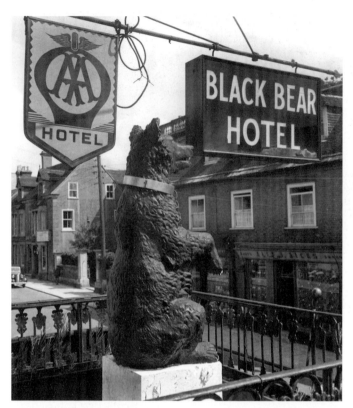

Left: Built in 1722, the Black Bear in South Street was once an important coaching inn. With its elegant façade and black bear above the portico, the hotel still welcomes guests. In November 1980, during the Court Leet proceedings, the black bear mysteriously turned yellow – like Rupert. But it did not last as the emulsion washed off with the first rain.

Below: Known centuries ago as the 'Ragged Cat', the Red Lion had Mr R. Lock listed as brewing in 1818. The hotel at the Town Cross was once Wareham's premier coaching inn and is still a popular venue. To the extreme left was the Angel, dating back to 1632. This was incorporated into the Red Lion in 1747.

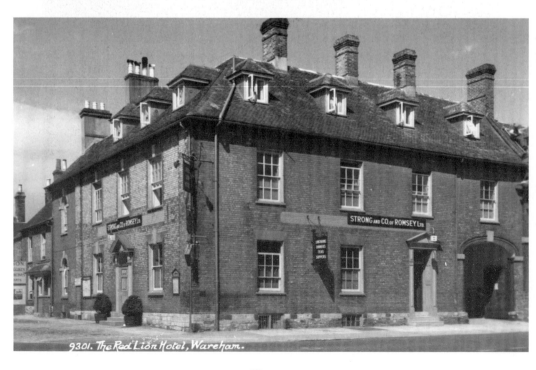

9301. The Red Lion Hotel, Wareham.

Ale tasters Mark Howlett and Steven Welsh at the award-winning Kings Arms in North Street. Behind the bar are Court Bailiff Hugh Elmes and landlady Julia Ballard. The Bailiff demands of the Ale Tasters: 'Ye shall duly and truly see that all brewers do brew good wholesome beer. All offences committed by brewers and innkeepers ye shall present to the Court'.

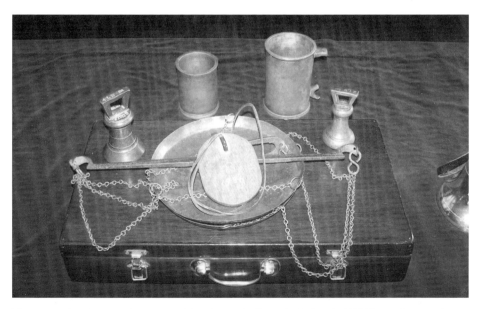

The Court Leet is an ancient manorial retinue of officers including Bailiff (Court Overseer), Hayward (enclosures and fences), Constable (law and order), Carniter (meat quality), Scavenger (lanes & privies), Ale Taster and Bread Weigher. Every November, Wareham's Court Leet performs ceremonial duties using the certified quart and pint pots and bread weighing scales.

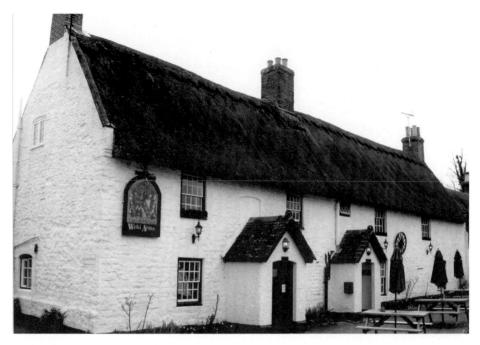

The Weld Arms is named after and owned by the landowning family who have lived at Lulworth since 1641. In the nineteenth century it brewed for the Weld estate and was then leased to Groves and, subsequently, Devenish of Weymouth. Three bars became one and there is an annual beer festival with a much appreciated free bus service.

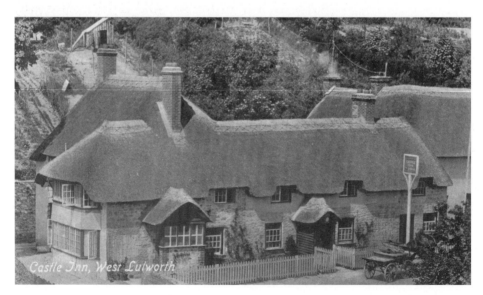

Dating back 400 years, the Castle Inn at West Lulworth changed its name from the Jolly Sailor after Lulworth Castle burnt down in 1929. Another home brew pub in the nineteenth century, it now has an excellent selection of local beers from the Isle of Purbeck Brewery, Dorset Brewing Company of Weymouth and the Dorset Piddle Brewery.

The Bear Hotel, Wool.

Once supplied by Bennetts Brewery of Wareham, the Black Bear Hotel at Wool was approaching the edge of 'Strong Country'. Now it is owned by Hall & Woodhouse and is a smart local. A mile to the west, J. Hall brewed at the old Seven Stars at East Burton in 1877. The pub was acquired by Groves in 1895.

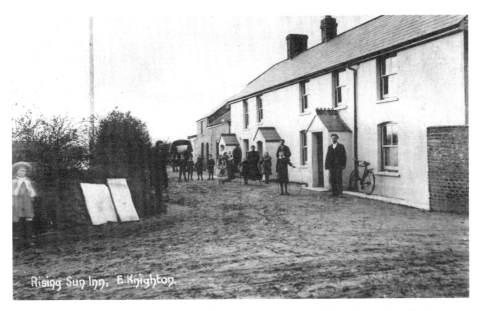

A century ago, thirsty locals and their children pose outside the Rising Sun at East Knighton, waiting for opening time. A former Devenish house, the pub has been renamed the Countryman Inn and renovated in a traditional style. The old locals would still feel at home as the inn remains a rural retreat.

Off the beaten track the Sailors Return at East Chaldon is well worth seeking out. Originally a pair of cottages, it became a pub around 1860. The pub sign tells of three brothers who joined the Navy. Two brothers returned, but one did not. When he unexpectedly did return, he found his unfaithful wife with her lover hiding behind a door ...

The Royal Oak at Bere Regis dates from the 1700s. About 1830, a brewery was established behind the pub. After several owners, Johnson & Tozer sold to Strongs in 1921. It was demolished in 1923 and a row of cottages bearing that date now occupies the site. Today the Royal Oak is a handsome inn with a pub/restaurant and a characterful coach house bar.

Blandford to Shaftesbury and Gillingham

Sympathetically rebuilt by Hall & Woodhouse in 1991 after a devastating fire, the Worlds End at Almer holds the oldest beer licence issued in Dorset. A story that General Montgomery planned the D-Day landings here is exaggerated – he stopped for lunch in 1940. Soldiers billeted locally used to fill up a tin bath with beer and scoop out glassfuls of ale.

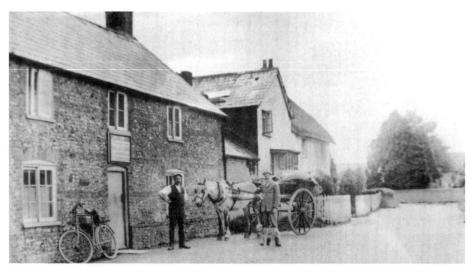

The Bush in Winterborne Kingston was a rarity in Dorset – it only had a 6 day licence. Craftily, beer was served on a Sunday as the landlord ran a 'slate'. A Hall & Woodhouse beerhouse, between 1921 and 1945 trade increased from 60 to 70 barrels a year. Despite a wine licence granted in 1948, the Bush closed in July 1965.

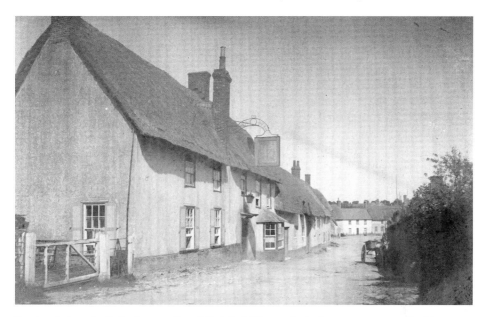

Previously just the Oak, the now Royal Oak in Milborne St Andrew was connected with Charles Warne of the Milton Brewery at Milton Abbas in the nineteenth century. Closed in 2008, the Royal Oak was thankfully reopened by Andrew and Sarah Fox in September 2009, after a plan by locals to run a community pub fell through.

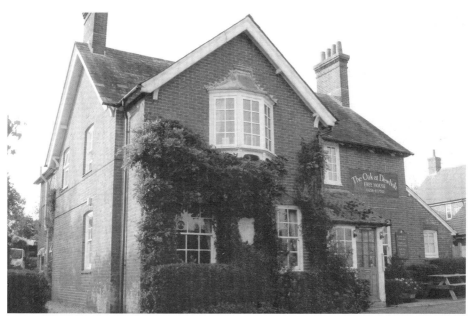

Well worth the trip to Dewlish, the Oak has a Hall & Woodhouse plaque dated 1906. It is now more of a village social club with changing guest ales. Nearby, opposite Parsonage Farm, the Dewlish Brewery burnt down in 1859. Founded by the Hall family, by 1751 it was run by William Hall, father of Charles Hall (Ansty Brewery).

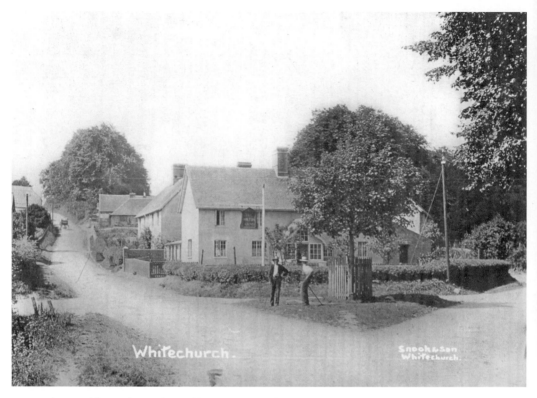

Previously served by Fookes Milton Abbas Brewery, today the Milton Arms in Winterborne
Whitechurch is still renowned for excellent ale quality. In 1932, the yearly rental to Henry Fookes
was just £25. Dating back to the seventeenth century, this well run pub is a strong village hub and
welcoming stop for travellers along the A354.

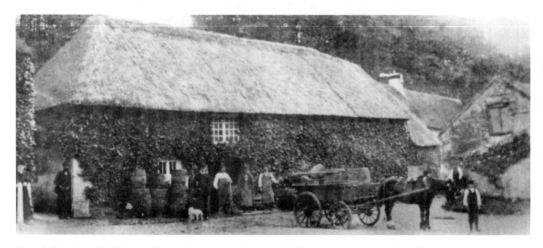

Founded in the old village before it was 'moved' by Lord Milton in the 1770s, the Milton Brewery
was at the bottom of the new village. It passed through the Ham and Warne families to Robert
Fookes in 1848. Years later, after Dunkirk, troops billeted nearby used the floor coolers for baths.

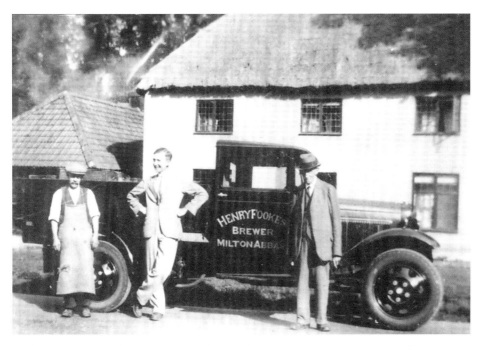

By the lorry are Ted Adams (Brewer), Arthur Fookes and Henry Fookes. Henry took on the business *c.* 1890 (with brother William until 1906). In 1950, it was sold to Groves of Weymouth with four pubs – the Milton Arms, Hambro Arms, Crown at Winterborne Stickland and Chequers at Lytchett Matravers.

At the other end of the picture book village to the old brewery, the Hambro Arms advertised in 1918 'Parties Catered For'. One such party is shown. Firstly named the Dorchester Arms, then Portarlington Arms, after the changing Lords of the Manor, the Hambro makes an excellent destination. The group of locals who own the pub still cater for parties.

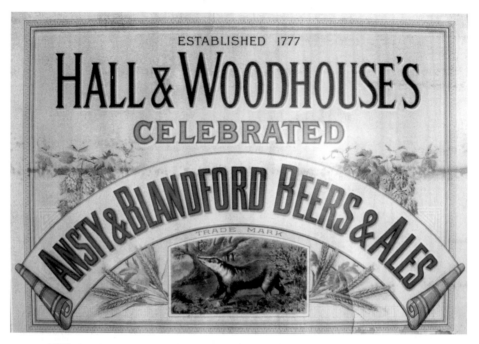

Charles Hall began brewing at Ansty in 1777, soon afterwards winning contracts to supply troops at Weymouth. His son, Robert, and G E I Woodhouse became partners in 1847. After several small acquisitions, in 1883 Hectors Brewery at Blandford St Mary was purchased. Brewing continued at both sites until 1900, when the business was transferred to the existing family-owned brewery.

Fifty years ago, the Charlton Inn at Charlton Marshall was the first of three Hall & Woodhouse pubs just south of Blandford. At Spetisbury, the Railway Inn has closed and the Drax Arms is sold and awaiting a revamp. With Jamie & Gemma running the Charlton Inn since early 2009, its reputation for service and excellent ales is being quickly re-established.

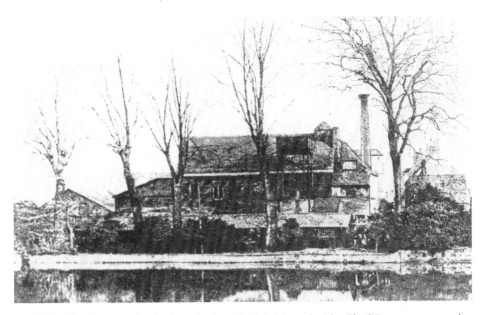

Established by the 1780s by the Stour in Blandford St Mary, the Blandford Brewery was run by John Hector from 1827 – 1879. Neame & Cook took over and sold to Hall & Woodhouse in 1883 with twelve pubs. It burned down on 14 August 1900. Hectors Brewery was remembered with Hectors Bitter from Hall & Woodhouse in the early 1980s.

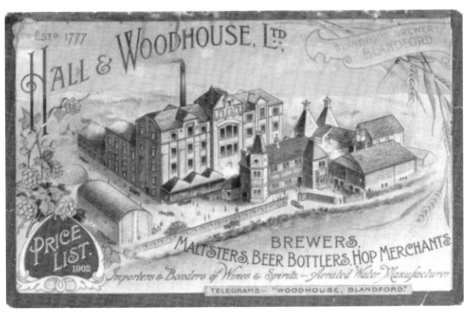

After the fire at Hectors Brewery, Ansty was used for all brewing until the new brewery at Blandford St Mary (already under construction) was ready for its first brew on 16 October 1900. Since then, pubs have been added to the estate with acquisitions from breweries at Fontmell Magna (1904), Marnhull (1912), Wimborne (1937), Wyke (1963) and Horsham (2000).

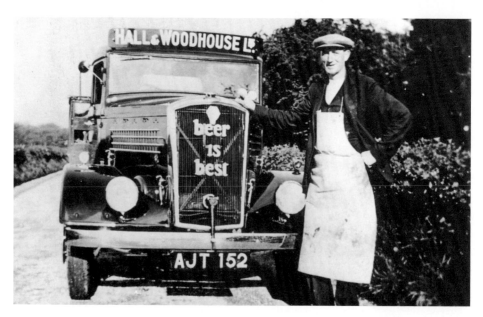

Harry Read was drayman when this photo was taken sixty years ago. Now, as ever, beer is still best. At Hall & Woodhouse, the pursuit of excellence continues. Badger First Gold (2005) and Tanglefoot (1987) have both been World Champions at the Brewing Industry International Awards. The bottled ale range continues to win major supermarket beer challenges with an unprecendented five Tesco Brewing Awards.

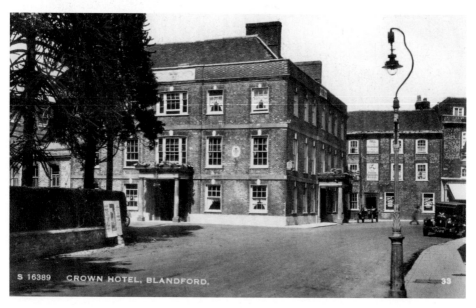

Prior to the fire at Blandford in 1731, the Crown Hotel in West Street was a fine galleried coaching inn. Now it is a grand Georgian style hotel and probably Dorset's oldest inn. Several brewers were at the Crown. The last, George Jones was given the hotel in 1918 by Lord Portman after a hunting accident. Jones sold to Hall & Woodhouse in 1931.

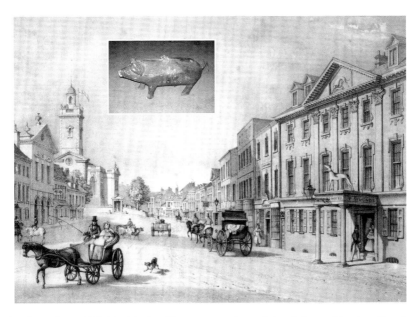

The Greyhound Inn (right) in Market Place was a substantial stylish coaching inn. By 1850, the coaching trade had declined so the front was let. The inn 'moved' through the arch to the tap room & brewhouse, and is still open. The blue pig is a surviving inn sign that hung next to the Town Hall advertising the Blue Boar Inn (1738-1840).

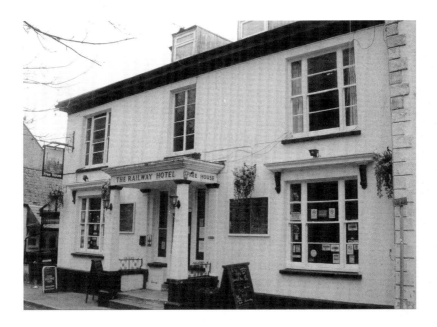

Built by Charles Godwin (of Shroton Brewery) in 1865 in Oakfield Street, the award-winning Railway Hotel is now a misnomer as there is no railway and it is not a hotel. It is, however, an excellent pub with ever changing ales, many from local breweries. Landlord Nigel Jones runs an increasingly popular beer festival on May Bank Holiday weekend.

Left: The eighteenth century George was at 26 Salisbury Street. Previously known as the Three Swans, the name changed in 1791 to commemorate George III passing through Blandford. At numbers 10 and 12 Salisbury Street, a substantial coaching inn called the George had existed from 1664. There was a brewhouse behind but the inn was not rebuilt after the 1731 fire.

Below: From the Blandford Directory 1907: 'Tea taken in excess has proved to be more harmful than Malt and Hop Beers in moderation. Many very aged persons in this town are living instances of Moderate use of Stimulants. Drink MARSH's Pure Malt and HOP ALES and live forever'. Unfortunately, Mr Marsh is no longer with us.

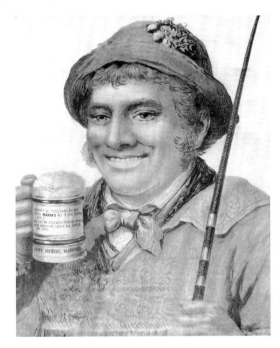

Right: The inscription on the drover's mug reads:
'When I be tired, vaint or dry
Then MARSH's ALES's the drink vor I
Do gee me strength to work apace
And makes me laugh all awver me face'

Below: Around 1912, J. L. Marsh stands at the front of the carnival float. The rear two boys standing on the right are Louis & Will Marsh who later ran the brewery. This is in the yard of Marsh's Town Brewery in Bryanston Street. Founded in 1735, behind the Kings Arms, it was sold to Simonds of Reading in 1939 with eight pubs.

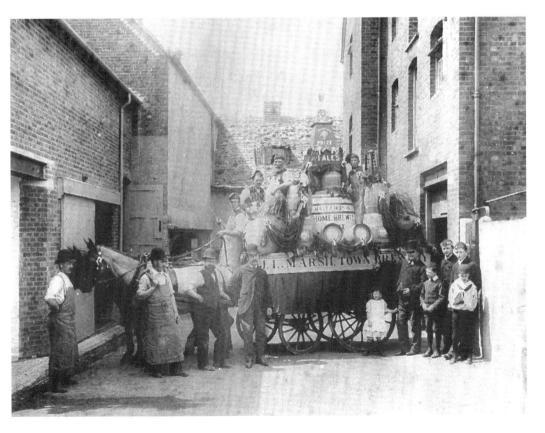

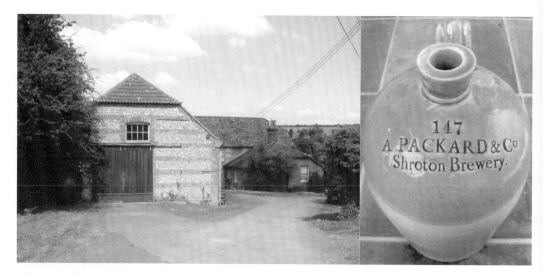

A few miles north of Blandford, Durweston and Shroton both had their own breweries. Mostly run by the Godwin family, much of Durweston Brewery (1753-1898) remains. Sold to Hall & Woodhouse, it is now the Old Brewery Workshops. The Shroton Brewery (1805-1889) was beyond the fine Cricketers pub. Sold to Flowers of Fontmell Magna, it is now a housing development.

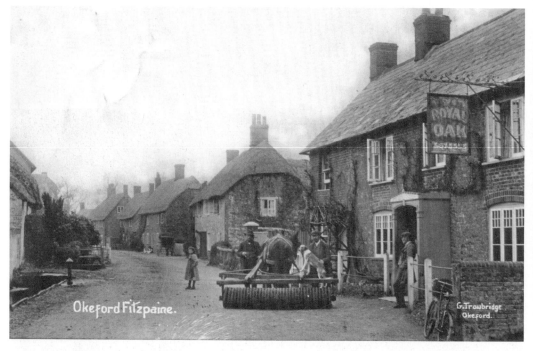

A superb seventeenth century pub, the Royal Oak is at the centre of the charming village of Okeford Fitzpaine. It has all the attributes of a traditional, well-run village inn – just draw up your horse or tractor! The annual beer festival is a triumph. In 2009, the Isle of Purbeck Brewery range and Elder Sarum from Small Paul of Gillingham were great successes.

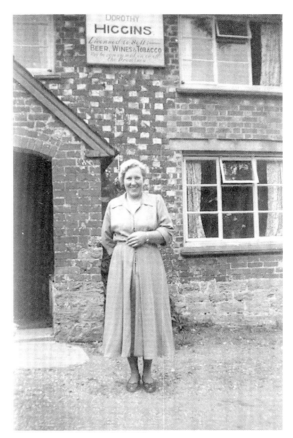

Right: Dorothy Higgins (a former landlady) stands outside the Drum & Monkey at Wonson, Hazelbury Bryan. A seventeenth century farmhouse, the inn was bought by Hall & Woodhouse in 1898 for £500. It sadly closed on 28 December 1969. There was a small marching drum hanging up inside. When visitors asked 'Where's the monkey?', the locals would reply 'Look at yourself in the mirror'.

Below: Firstly Thomas Shittler brewed and then his widow Mary, at the Antelope in Hazelbury Bryan. She sold to Hall & Woodhouse in 1875 with three other pubs. Hall & Woodhouse recently sold the pub but it still offers Dorset ales. It is a lovely, traditional, classic rural pub and forms a valued village centre with the Community Shop opposite.

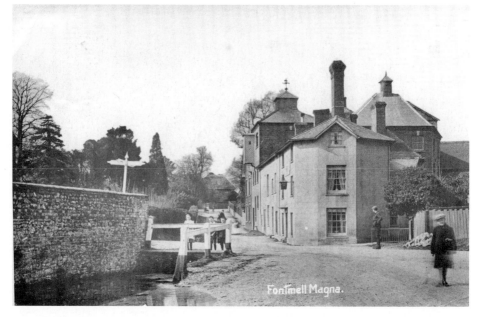

The award-winning Crown at Fontmell Magna is a comfortable, country style inn. It has its own 'grey lady', and a stream running past the back wall. Attached to the Crown, the old brewery (1780-1904) was run by the Monckton, Flower & Sibeth families for most of its life. The Flowers were innovators in brewing equipment such as crown capping machinery.

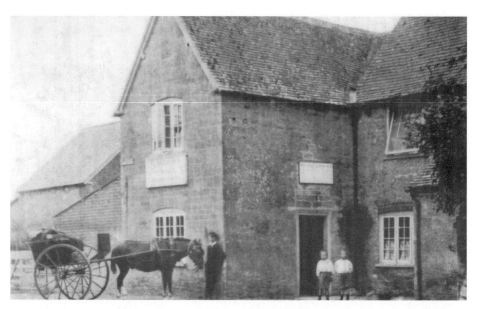

The boys by the door of the Plough at Manston were two of triplets born to Mr and Mrs Courage (landlords) in Edwardian times. Their brother drowned but his ghost still plays by the fireplace. Phil and Ann Basford now run the Plough and its successful beer festival. With a distinctive moulded plaster ceiling, it is a gem of a traditional rural free house.

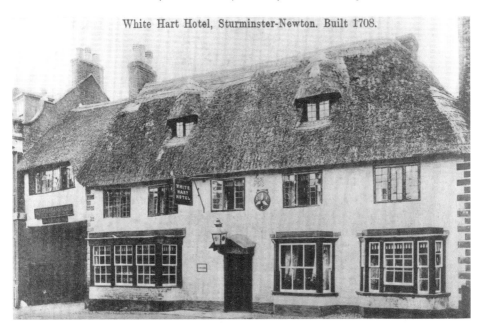

It is said that only the White Hart and the Church survived Sturminster Newton's fire of 1729. Shortly afterwards brewing started at the inn. Latterly, Harry Chapman sold to Hall & Woodhouse in about 1910. The Blandford brewer had five pubs here fifty years ago. The Red Lion and Rivers Arms closed mid-1990s and the Bull, and Swan survive.

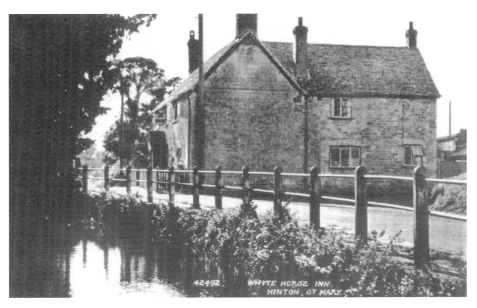

A worthy inclusion in CAMRA's *Good Beer Guide* and just off the main road in Hinton St Mary, the White Horse is a charming pub in a charming village. This is a traditional pub – homely and welcoming with no TV, music or games machines. There are ever-changing, carefully chosen guest ales at what is, quite simply, a lovely pub.

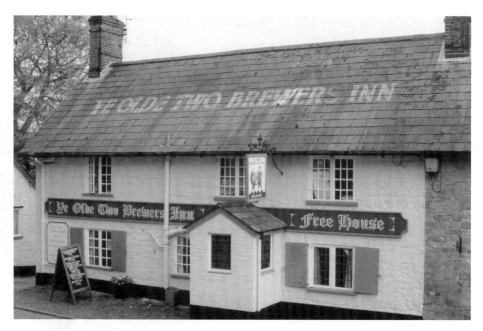

Ye Olde Two Brewers is a super eighteenth century pub in St James Street at the bottom of Gold Hill, Shaftesbury. Its name probably comes from the days before tied houses, when two travelling brewers brought their beer to inns, especially at festival times. The pub still offers a great selection of ales and is worth seeking out.

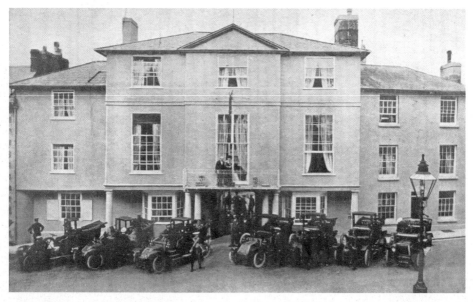

Previously the New Inn and Red Lion, the Grosvenor Hotel in The Commons assumed its current name in 1848. Closed for years, it is now being renovated with a development of twenty-four flats to the rear. It has vast cellars with a secret tunnel to allow gentlemen discreet passage to and from the Butt of Sherry opposite, either for drinking or other activities!

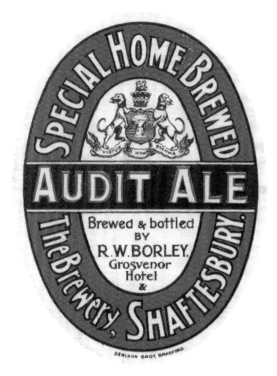

Right: At least a dozen pubs were brewing in Shaftesbury in the eighteenth and nineteenth centuries. Perhaps the best known brewers were Robert William Borley who brewed at the Grosvenor Hotel and the Kings Arms, and WE Watts who owned the Butt of Sherry. He brewed at a small brewery in St James Street (formerly the Fox & Hounds Inn).

Below: The current Ship Inn on the corner of Blake Street and Tout Hill used to be the surgery of Dr Harris up to the early 1930s. Since ale is the best medicine, it changed to a super multi-roomed pub with a snug. The previous Ship, near the Grosvenor, was a homebrew pub. J. C. Highman was bought out in 1916 by Matthews of Wyke.

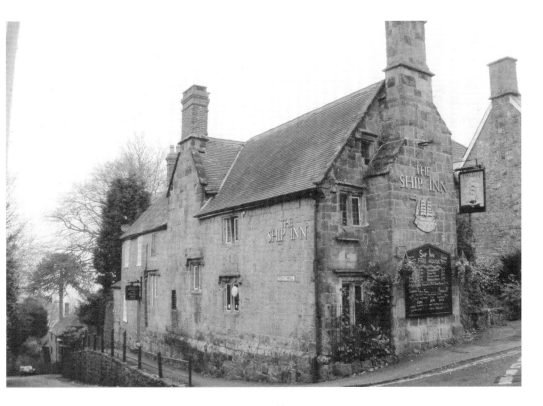

Left: At one time, Marnhull had two breweries and five malthouses. The Marnhull Brewery (1821-1913) in Carraway Lane struggled to attract investors, especially with agriculture in decline. The tower remains but it was much larger. Nearby, the Walton Elm or Poplar Elm Brewery (c. 1815-1892), was at Hingarston House. Their ales were supposedly inferior as Marnhull Brewery was first on the water supply.

Below: The Crown at Marnhull was Thomas Hardy's 'Pure Drop Inn' in *Tess of the d'Urbervilles*. It is a superb Hall & Woodhouse establishment with wonderful, traditional features such as a priest hole. There was a brewhouse next to the inn (William Galpin was there in 1753), but only a wall remains. In 1842, the premises were acquired by Marnhull Brewery and brewing ceased.

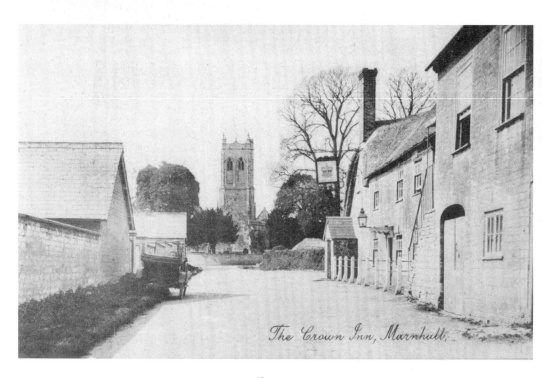

The Crown Inn, Marnhull.

On a bend in the Great Western Road (now A30) at West Stour stands the imposing and impressive Ship Inn. A coaching inn built in 1750, it was the last change of horses before the steep climb to Shaftesbury. An 1830 sale document lists a brewhouse, and a number of brewers were at the Ship from 1753 until it was acquired by Matthews in 1870.

The CAMRA award-winning Stapleton Arms at Buckhorn Weston is a real juxtaposed triumph – an inn with a very traditional exterior (portico etc) and a quasi-bohemian interior (bold colours, new bar etc) and it totally works. There are up to five real ales (some local), ciders, a wide range of bottled beer and locally made pork pies and pickle on the bar. Heaven.

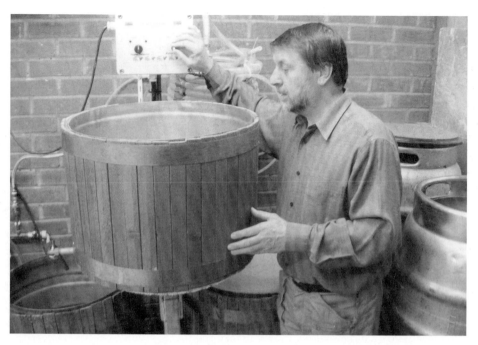

Paul Smith aka 'Small Paul' started his bijou brewery in September 2006 in a corner of his garage in Gillingham. Each brew produces two nine gallon casks of wonderful ale. The kit is very ingenious – fumes are extracted through an adapted compost bin lid, but this is a professional operation with duty paid on award-winning beers.

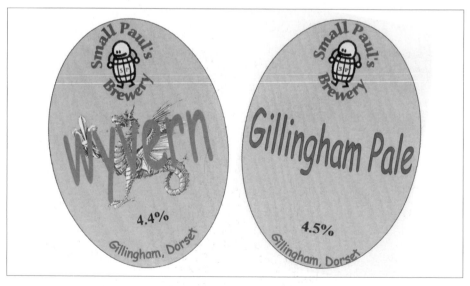

Due to his location, Small Paul sells to pubs in three counties – Wiltshire, Somerset and Dorset – the Smouldering Boulder in Gillingham and the Ship at West Stour being regular outlets. He also supplies local beer festivals and Gillingham Pale was voted Beer of the Festival at the renowned Overton Festival in 2008. Gylla's Gold and Elder Sarum complete the current range.

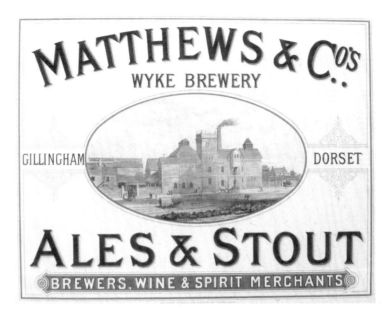

West of Gillingham at Wyke, a substantial part of the old Matthews Brewery still stands, converted into flats in the mid 1980's. The Matthews family started brewing behind the Drum & Monkey at Wyke in 1750. After a fire, the large architect-designed 'brewers castle' was completed about 1860. After several approaches, Hall & Woodhouse acquired Matthews in 1963 with sixty-one tied houses.

After the 1963 takeover by Hall & Woodhouse, brewing ceased and the huge premises were used as a bottling store until the 1970s. The Drum & Monkey had been rebuilt and named the Buffalo after the charging buffalo that was the Matthews Brewery trademark. The Buffalo was the brewery tap and is still a very popular Hall & Woodhouse pub.

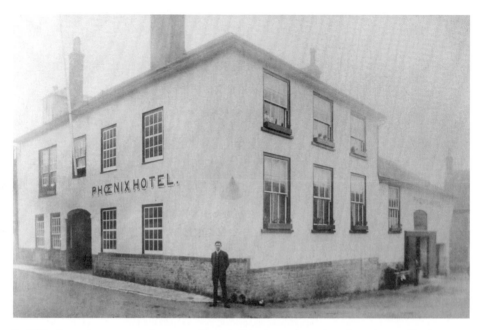

In Gillingham, the seventeenth century Phoenix Hotel rose from the ashes of an earlier inn. The Goldsborough family brewed here from 1833 to 1875 when they sold to Matthews with another brewpub, the Red Lion at Bourton. In the 1940s risqué parties were held at the hotel. After subsequent division, the award-winning smaller pub is homely and welcoming.

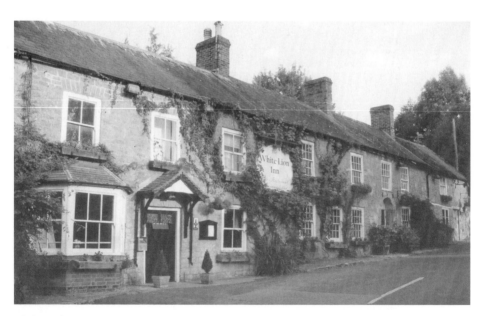

Close to the three counties stone, and the northernmost pub in Dorset, the White Lion at Bourton is an excellent traditional pub. From the mid nineteenth century, the Ing family brewed for farm workers in a shed to the rear. The brewery grew until acquired by Frome United Breweries (Somerset) in the 1890s. A great selection of foaming ales is still available.

Portland and Weymouth to Abbotsbury

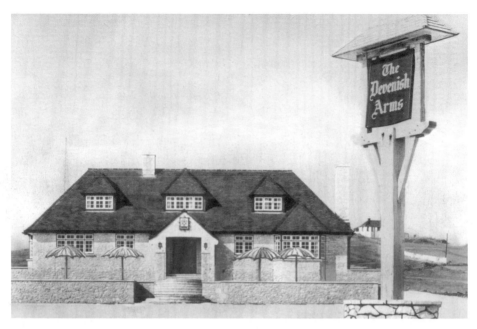

From the northernmost pub to the most southerly – the Pulpit Inn (previously Devenish Arms), overlooks the Portland Bill Lighthouse. Renamed after the nearby Pulpit Rock, the pub's original name came from the Weymouth brewery that built it in 1954. Viewed from the open plan bars, the sea 'boils' where the tidal race meets the Shambles sandbank.

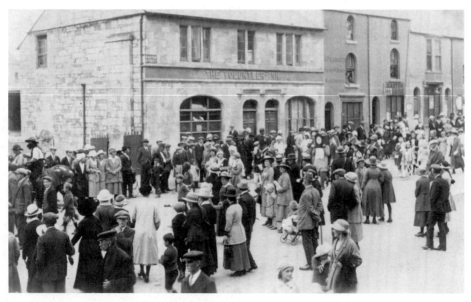

An early twentieth century parade passes by the Volunteer Inn at Easton. A hundred years ago, the Volunteer (now an Estate Agent) was one of over forty inns on Portland – there were very thirsty quarrymen, sailors and soldiers. Fifty years ago, there were still over thirty pubs and today about half that, with all contributing to Portland's distinctive character.

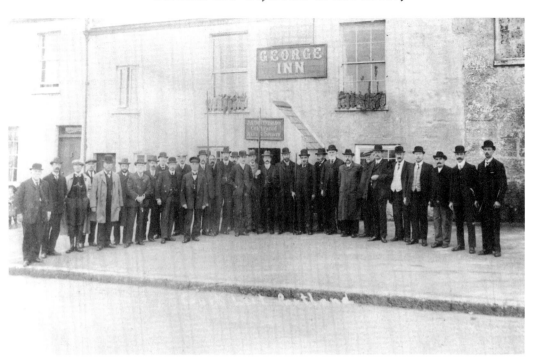

Above: Built in 1610 as a house for the Clerk of the Court Leet (see Chapter 2), the George Inn at Reforne has existed here since 1805. The Jacobean building is wonderful and the well-run pub has ales from the Dorset Brewing Co of Weymouth. Oddly enough, there is a gravestone in the back garden for someone not yet deceased.

Right: The Royal Portland Arms at Fortuneswell is a great old inn – the oldest on Portland. George III stopped here several times, lunching on Royal Pudding (with Portland mutton) followed by plum pudding. Now there is an ever changing selection of mostly Dorset beers, with always at least one from the Dorset Brewing Co – ales fit for a King.

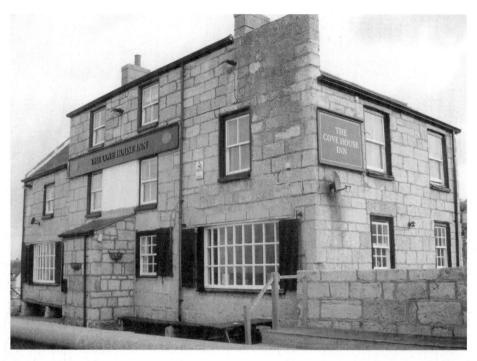

The Cove House Inn at Chiswell sits at the very eastern end of Chesil Beach – home of Veasta. Constructed from giant blocks, it has withstood the storms that have caused so many wrecks within sight of the pub. At 88 Chiswell, by the old Kings Arms, there was a short-lived brewery run by Mr Comben. It had closed by 1885.

By the Naval Dockyard gates at Castletown, there were the Sailors Return (closed), Albert (now Green Shutters), Royal Breakwater Hotel, Portland Roads Hotel, Jolly Sailor (closed) and Castle Hotel (now Hotel Aqua). All were ready for hundreds of off-duty sailors. Soon they will buzz again as the centre of the 2012 Olympic sailing events. © Stuart Morris Collection.

Above: A century ago, the pianist plays on to the few ratings in the Portland Naval Canteen. The beer advertised above the bar is from Portsmouth United Breweries, sadly not from Groves or Devenish of Weymouth. At least there are six hand pumps to dispense ale when the Fleet arrives.

Right: Only the Albert Inn survives in 'old' Wyke Regis. The Swan is now a private house. The ancient Ship Inn in Shrubbery Lane was destroyed by German bombers on 28 June 1942. Kate Bilke, wife of landlord John, was among the five people killed in the raid. Nearby, the Wyke Regis Brewery (1843-1877) was acquired by Groves with seven pubs.

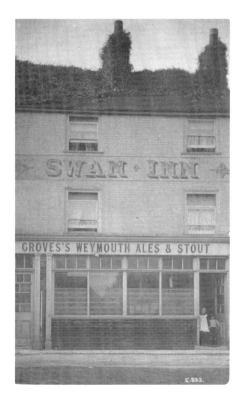

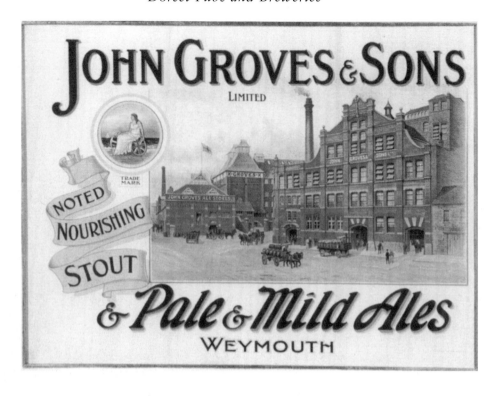

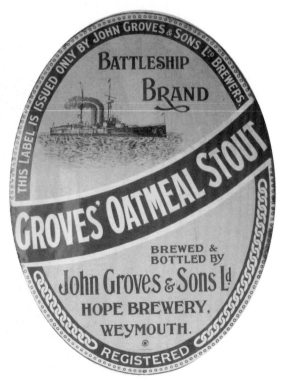

Above: Brewing has taken place around Hope Square in Weymouth since 1252 and at one time there were three breweries operating. A relative late-comer, Levi Groves founded the Hope Brewery in 1840. After 'much inconvenience and vexatious delay' (Herbert J. Groves), the Arthur Kinder designed Groves Brewery was completed in 1904, and remains to this day as Brewers Quay.

Left: Groves Brewery expanded with acquisitions of breweries in Weymouth (Melcombe), Portland (Chesil), Dorchester (Phoenix), Wimborne (Julian), Milton Abbas (Milton) and several homebrew pubs. An unfriendly rivalry existed with the Devenish Brewery next door – staff voted against a joint sports club, but from the 1920s amalgamation with Devenish was considered. Finally in 1960, Devenish acquired Groves with 115 pubs.

Right: The Fowler family founded the Weymouth Brewery in Hope Square in 1742, William Devenish leased it in 1824 and the Devenish estate grew mainly by brewery purchases in Cornwall and Devon. Five Royal Warrants were awarded and 1960 saw the prized purchase of Groves. Devenish was absorbed into the Inn Leisure Group and brewing in Weymouth ceased in November 1985.

Below: The Devenish Fire Brigade was called into action on 11 August 1940 and 7 May 1941, when German bombs fell on the brewery and bottling stores. While rebuilding took place, Groves and Eldridge Pope of Dorchester both brewed for Devenish at cost plus 8 shillings per barrel. By June 1942, the repairs were finished and the battle between the breweries recommenced.

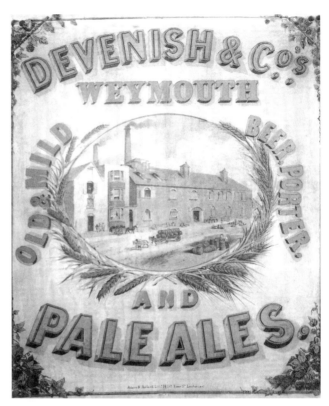

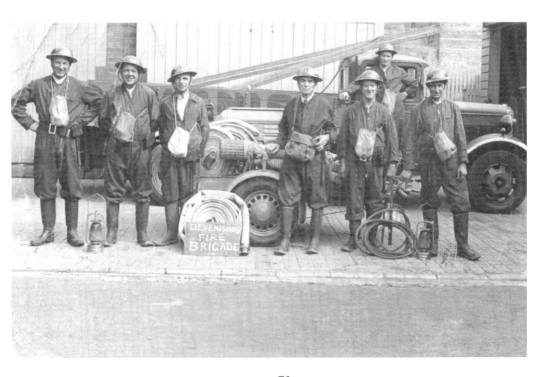

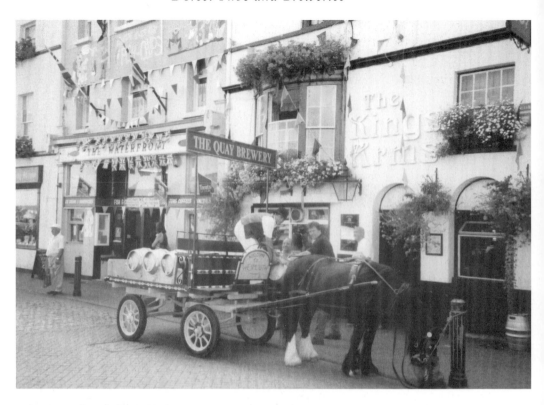

Above: After a gap of eleven years, brewing returned to Brewers Quay. The Quay Brewery was founded by Giles Smeath with help from brewer John Nicholson. The first brew in Summer 1996 was transported by horse-drawn dray from Brewers Quay to the excellent Kings Arms 250 yards away. An expectant crowd waited thirty minutes while the 'country horse' toured the square ten times.

Left: The Quay Brewery quickly established itself and started winning awards with wheat beers Silent Knight and Summer Knight. The distinctive pump-clip design appeared in more pubs and the brewery supplied the house ale for the Shave Cross Inn. Bottle conditioned beers in flip-top bottles sold well and one beer – Bombshell Bitter – commemorated the bombing of Devenish in 1940.

Above: In 2004, the Quay Brewery changed its name to the Dorset Brewing Company. With help from family members and new brewer Peter Bird, DBC beers such as Jurassic, Durdle Door, Chesil and Ammonite are available in over 100 outlets. DBC recently acquired Tom Browns with the Goldfinch Brewery in Dorchester and plan to restart brewing there.

Right: Mrs Cecil Pope performed the opening ceremony of the Admiral Hardy in Chickerell Road on 15 December 1958. It was the first new licensed house to be built in the Weymouth area since the war (the licence was transferred from the Lamb & Flag). Now a well-liked local, its handsome sign was painted for Eldridge Pope by Brewery Artists at Cheltenham.

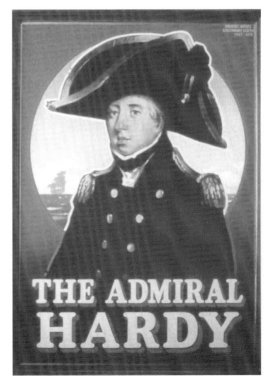

One of Weymouth's most lauded pubs and CAMRA multi award-winning, the Boat is in the old High Street behind the Fire Station. A flagship for Ringwood Brewery, it has their full range, with guest beers usually from regional breweries. There has been an alehouse on the site since the fourteenth century and it remains a beacon to beer-drinkers.

Harbour-side on Custom House Quay sits the Ship Inn. Fifty years ago it was one of only two Hall & Woodhouse hostelries in Weymouth – the other was the Portland Railway Hotel in King Street. To the rear, the massive 'Red Warehouse' (which included Eldridge Pope's bonded stores) was demolished in 1958 and years later replaced by an extension to the Ship.

Also on Custom House Quay, the Royal Oak is now effectively the tap for the Dorset Brewing Company. A superb selection of their beers is always available. On the walls, there are many old photos of the 'good old days' of Devenish & Groves. Another water-side pub worth visiting is the Sailors Return with its nautical atmosphere and local ales.

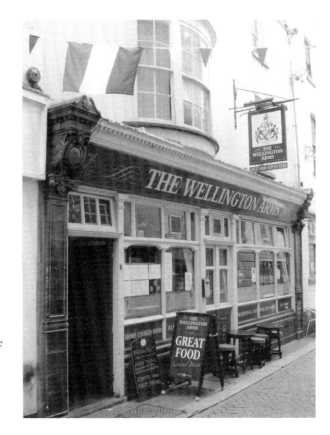

An oasis in the town centre, the family run Wellington Arms in St Albans Street is a cosy, ex-Eldridge Pope house. The building itself is sixteenth century and the unpretentious pub has changed little over the past fifty years. The green and gold tiled frontage is Grade II listed and dates from around 1850. The 'Wellie' is a proper, traditional pub.

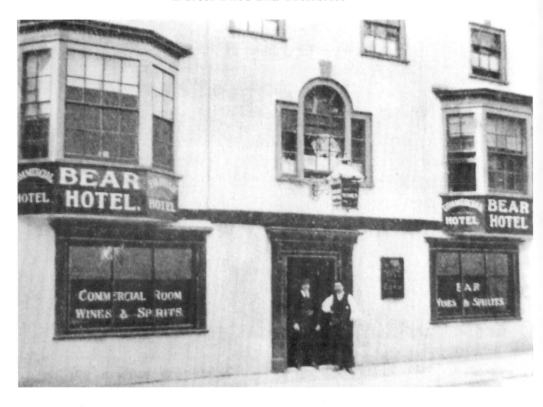

Above: The front entrance to the Bear Hotel was in St Mary Street and offset to the rear was a small brewery among the stables. The brewery operated for several hundred years until the nineteenth century, while the hotel lasted until 1929. There were other breweries, at the Dove (now Black Dog) and on the site of the Swan (now a Wetherspoons' pub).

Left: Standing alone and looking incongruous alongside the recent Debenhams development, the White Hart has been totally refurbished with an open-plan interior. The hostelry dates from the early seventeenth century and is reputedly the birthplace of Sir James Thornhill, one of whose students, and later son-in-law, was William Hogarth. Today it is a haven for weary shoppers.

When the Naval base was operational, there were twenty-two pubs around Weymouth railway station. Just down Park Street is the Dolphin Inn – another former Devenish house which was reopened in 2002 by the Hopback Brewery of Salisbury. Peering in through the appealing leaded windows, a deceptively spacious, bright & airy interior is revealed. The refreshing Hopback range is served.

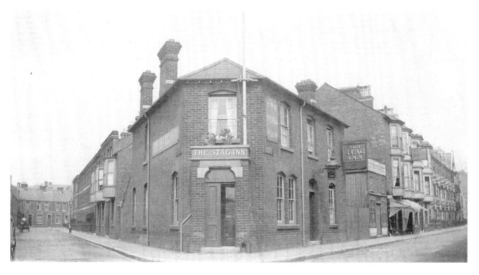

In a Devenish guide, the Stag Inn was described as a 'comfortable hostelry and an extremely useful one for the over-night visitor'. Off the northern end of the Esplanade, on the corner of Lennox Street and Walpole Street, the Stag was typical of the traditional back street local. Sadly, many such pubs have closed and the Stag is now a Mace convenience store.

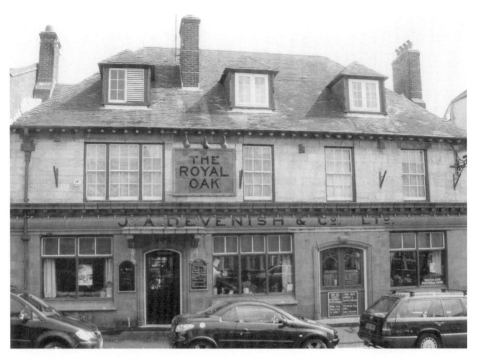

On the Dorchester Road, there exists Weymouth's second Royal Oak. The pub has a fine faience (glazed moulded brick) frontage – one of only two such Devenish exteriors left. The other, in Castletown, is on the newly renovated Portland Roads Hotel whose imposing yellow/brown frontage was supplied by Burmantofts of Leeds.

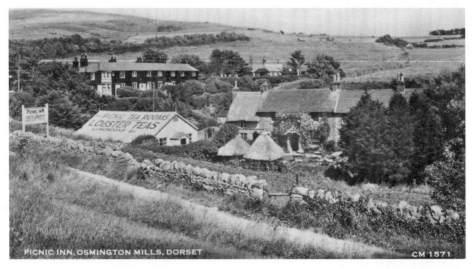

In parts 700 years old, the Smugglers Inn at Osmington Mills is hugely popular. Previously the Picnic Inn and, before that, the Crown, it is the romance of its new name that captures the imagination. Infamous smuggler 'French Peter' who had five Customs ships looking for him, and landlord Emmanuel Carless used the safe beach below to land their contraband.

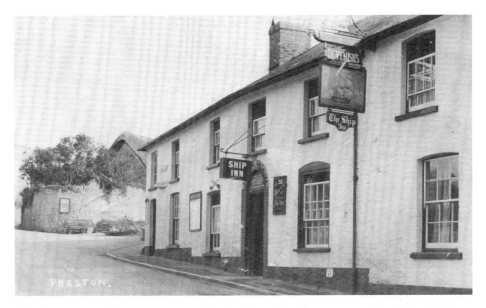

The Ship at Preston has now become the Spice Ship and has been renovated and extended in a traditional style. It is well-renowned and usually busy, as is the nearby Bridge Inn. At the Spice Ship, strange happenings are put down to the ghost of a drowned Portuguese sailor searching for his lost shipmates.

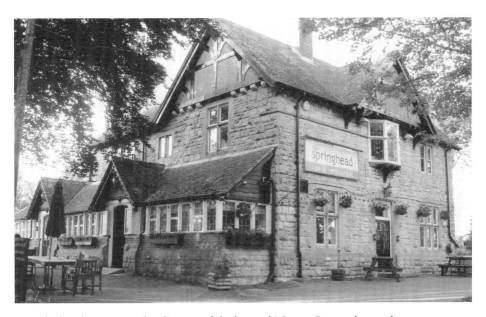

Described in the 1950s as the 'disgrace of the borough' Sutton Poyntz then underwent restoration. The stagnant duck pond was cleared and cottages renovated. Today it is a delightful village. It is home to the pumping station for Weymouth's water supply (the funnel of Brunel's Great Eastern is still adapted as a filter) and also the Springhead – a large, comfortable food-led pub.

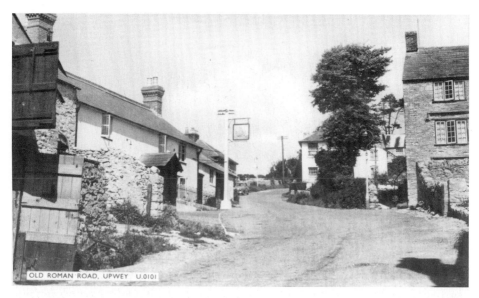

OLD ROMAN ROAD, UPWEY U.0101

Just off the main road on the old Roman road at Upwey, is the Old Ship Inn. Definitely worth visiting, it is a well-run pub appreciated by both locals and visitors. Beer quality is top-notch, with locally sourced guest ales. The interior has exposed beams and stone walls, all adding to the appeal of this 400 year-old pub.

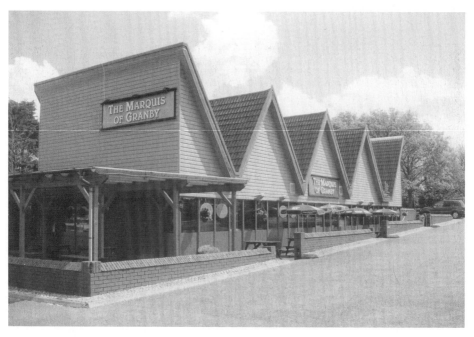

Replacing a Victorian building, the new Marquis of Granby in Charlestown (just west of Weymouth) made a bold statement in 1978. The pub was renamed the Swiss Cottage for a while but has reverted to its original name. On the inn sign, the Marquis is shown as a balding man as in 1760 his wig allegedly fell off during a battle charge.

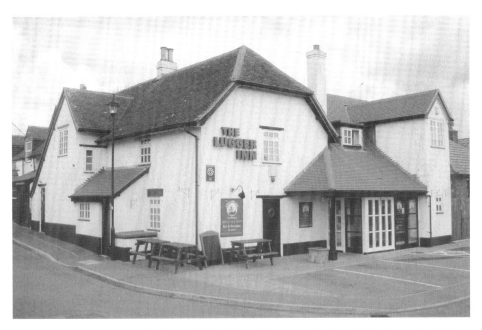

After a serious restoration which saved the eighteenth century inn from falling in on itself, the Lugger at Chickerell has been reborn. The transformation is shown in a series of photographs in the inn and the results are superb. The inn also sells its own Lugger Ale (rebadged Dorset Brewing Co. Bitter) and hosts beer-lover's breaks.

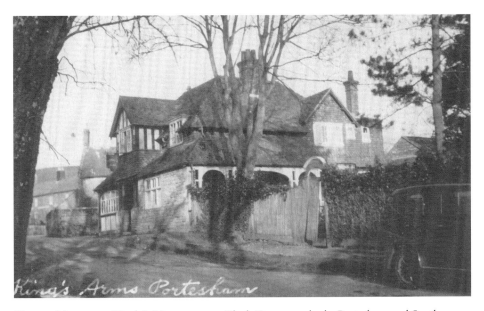

Thomas Masterman Hardy's Monument on Black Down overlooks Portesham and South Dorset. From the age of nine, Hardy lived at Portesham House, opposite the Kings Arms. The pub had its own memorial, the Hardy Bar, which recreated his cabin on HMS *Victory*. Alas, the bar has gone, but the tradition of good beer and service continues at the Kings Arms.

Next to James Stickland's smithy at Portesham, and up from the Kings Arms, was a traditional, rural inn – the Half Moon. It closed some decades ago, joining the earlier Fountain Inn (now the village stores). The Fountain had been a home-brew pub in the nineteenth century but was bought by Devenish and does not appear in twentieth century directories.

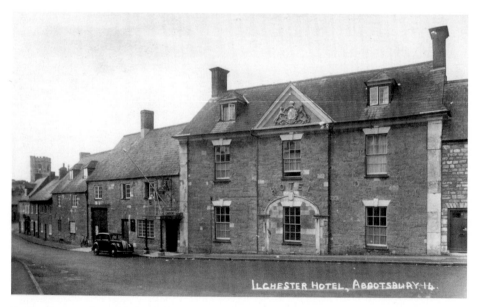

Earlier features abound behind the 300 year old, yellowed stone Georgian façade of the Ilchester Arms at Abbotsbury. Established by monks in ancient times, it was remodelled as a coaching inn (then called the Ship) and had a reputation as a distribution centre for smuggled goods. Today it is a comfortable, rambling hotel with a good selection of beers.

five

Dorchester to Sherborne

At West Knighton, the New Inn is a super well-run rural village pub. Built in the eighteenth century as farm cottages, the roof is edged in stone slabs in true Dorset style. In the nineteenth century, it was a homebrew inn with Joseph Boyt listed as landlord/brewer in 1848. Later on, it was acquired by Groves of Weymouth.

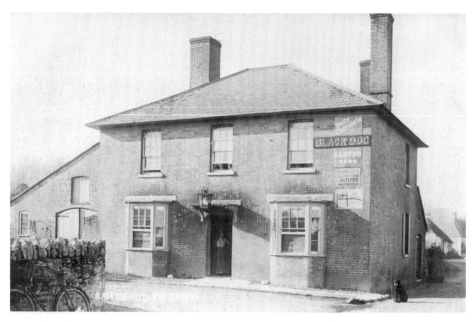

Now the only pub in the village, the Black Dog at Broadmayne is a real focal point for locals. Built in the late 1800s out of local Broadmayne brick, it was certainly an inn by the mid-nineteenth century when Thomas Foot was the landlord. Much extended over the years a good selection of well kept ales is available.

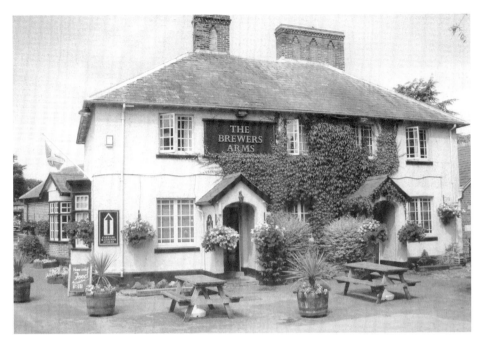

The Scutt family lived in Brewery House, Martinstown and brewed ale for the village from the 1840s. In 1865, the Brewers Arms began trading and in 1880 William Scutt took the lease. Groves bought the pub in 1889 and the Scutts ceased brewing six years later. Today the Brewers Arms sells Weymouth beers again and is an interesting pub to visit.

The Tolpuddle Martyrs would have known the Crown Inn like this. A nineteenth century homebrew inn, it was sold to Hall & Woodhouse in 1880. In the 1920s it burnt down and was rebuilt as the current pub. The name changed to the Martyrs Inn in 1971 and bottled Martyrs Ale was sold in 1984 for the 150th anniversary of the Martyrs' arrests.

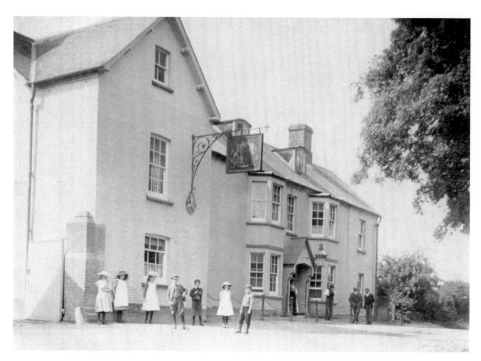

The sixteenth century Kings Arms at Puddletown was a grand old mail coach inn. In the stable yard was a small brewery which was used for well over a century until the 1870s. It was bought by Marshs (Blandford) then went to Simonds (Reading) then to Brutton, Mitchell & Toms (Yeovil) then to Charringtons (London) and finally to Bass Charringtons South West.

Just north of Puddletown village centre is the Blue Vinny pub. Named after the Dorset cheese, it is worth visiting for a taste. However, some say that the Blue Vinny today is softer and creamier and that past cheeses could be used as wheels on wheelbarrows. Others, that the strain of mould died out when production declined and the new cheeses taste different.

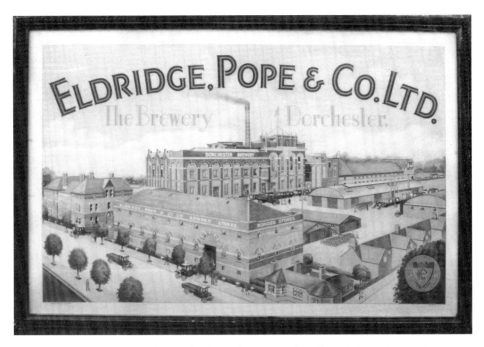

From 1837, Charles and Sarah Eldridge brewed porter at the enlarged Green Dragon Brewery in Dorchester. After Charles' death, lighter ales were also brewed at the Pale Ale Brewery in High East Street. Then trading as Eldridge & Mason, Alfred Pope invested in 1871 and ten years later opened Eldridge Pope's 'noble and imposing' brewery in Weymouth Avenue. After a fire in 1922, the brewery was remodelled.

From the 'Huntsman' 1974 (Eldridge Pope magazine), 'The trend in demand has accelerated towards keg beer and in particular lager. Our keg beer sales are now four times the 1969 volume'. 1974 was also the year CAMRA was formed. However, Dorchester was to lose Eldridge Pope within thirty years. The pub estate was sold in 1997 and the brewery closed in 2003.

Left: Long ago in Dorchester, the Plume of Feathers in Princes Street was one of several homebrew inns such as the Borough Arms, Royal Oak and Star. The Taylor family brewed at the 'Feathers' for fifty years until it was acquired by Groves in 1903. It closed in the 1970's and is now offices, but for a time was home to smashing Dorset FM.

Below: Between the Icen Way and Church Street turnings in High East Street was the Phoenix Hotel. To the rear, the Galpin family founded a brewery in the late eighteenth century. Originally rivalling the Green Dragon Brewery, the Phoenix Brewery expanded into Church Street. However, trade did not flourish and it was acquired by Groves in 1898 with five pubs.

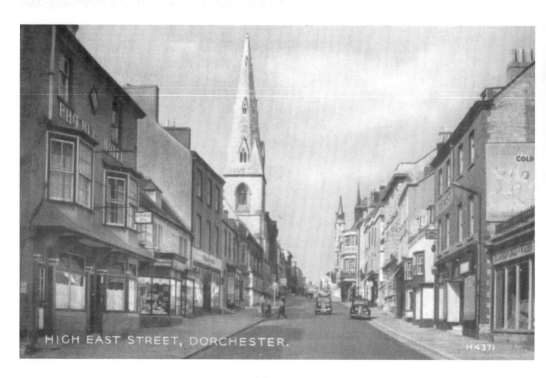

HIGH EAST STREET, DORCHESTER.

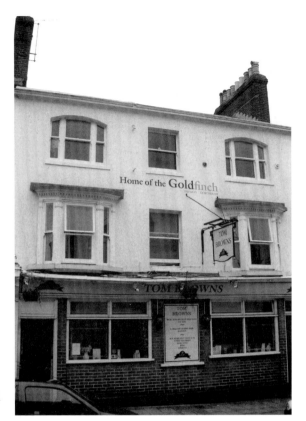

In 1987, Simon Finch established the Goldfinch Brewery behind 47 High East Street in Tom Browns pub. Another Tom Browns was opened in Salisbury in 1995. The cask beers are Tom Browns Best Bitter, Flashmans Clout Strong Ale and Midnight Blinder. Sadly the brewer died in 2005 and the pubs were acquired by Owl Taverns of Thame, Oxfordshire.

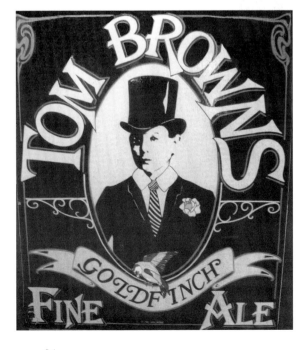

Tom Browns, formerly the Buffers Inn and before that the Chequers Hotel, is now managed by the Dorset Brewing Company. They have injected some life back into the pub with mini beer festivals and competitions involving unusual pub games. Also DBC aim to restart brewing at the pub, with either beer or cider in the pipeline.

91

White Hart Hotel, Dorchester. Hills & Rowneys Series.

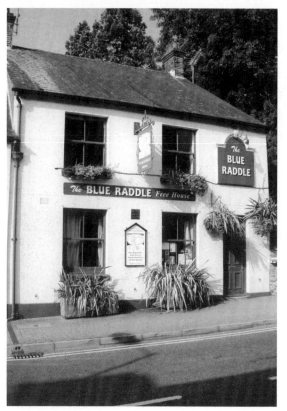

Above: At the bottom of High East Street there is a sorry sight – the boarded up White Hart Hotel. In 1792, the Beasant family set up a small brewery which continued until 1860, when the White Hart was bought by Hall & Woodhouse. The hotel was a favourite with local carriers, especially on market days with wagons of every description coming and going.

Left: Next to the graveyard in Church Street there is a small pub. Previous incarnations the Dolphin Inn and Country Gentleman were nothing out of the ordinary but the current Blue Raddle is. This is a proper pub with an ever-changing range of mainly west country ales. Also, a trip to the amenities has an unusual twist.

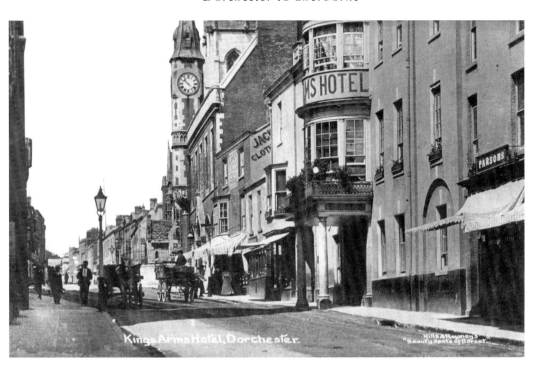

Above: The seventeenth century Kings Arms Hotel vied for position as Dorchester's top coaching inn – an accolade shared with another inn. Royalty, aristocrats and celebrities have stayed at the Kings Arms and in the nineteenth century it catered for over forty coaches a week. Thomas Hardy described the hotel in The Mayor of Casterbridge and today there is a lovely low-beamed bar serving local ales.

Right: In Cornhill, the Antelope Hotel was Dorchester's other top coaching inn. At the hotel, brewing was sporadic up to the 1850s and Charles Eldridge was landlord from 1833 to 1835 before launching the enlarged Green Dragon Brewery. When telephones first appeared, the Antelope was known as 'Dorchester One' but now the interior has been gutted and replaced by a shopping arcade.

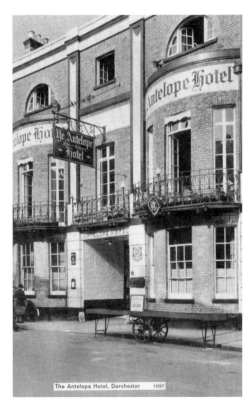

93

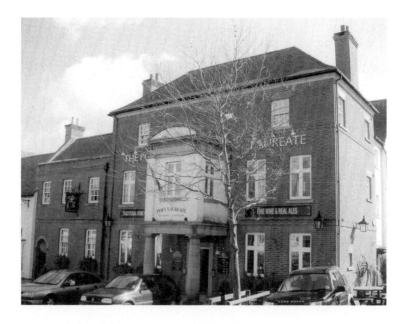

West Dorset's newest pub, the Poet Laureate in Pummery Square, Poundbury opened in November 2002. The Poundberry Estate is affectionately known as 'Charlestown' after the Prince of Wales, who conceived the idea for a self-contained extension to Dorchester. The pub, named after Ted Hughes, is a pleasing attempt at recreating a rather grand, town square pub.

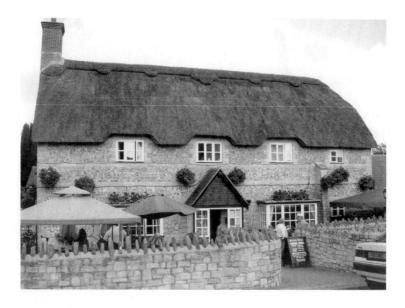

After the closure of the Bull Inn (in the mid 1980s) the residents of Stratton were lucky to have the thatch and flint Saxon Arms built in their village. Opened in 2001 and a CAMRA Good Beer Guide regular, the Saxon is a popular community hub. The pub is well run by Rod and Janette Lamont and also sponsors three local sports teams.

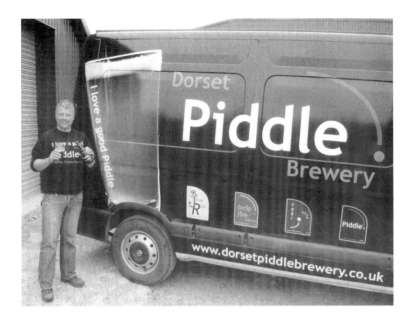

It is not often that a request for 'a pint of Piddle' is met with a positive response but this really happens in over 100 pubs. The Dorset Piddle Brewery in Piddlehinton was set up in 1997 by Rob Martin (pictured) and Paul Goldsack, both from the award-winning Ye Olde George Inn at Christchurch. Cask and bottled ales are equally successful and plaudits keep flowing in.

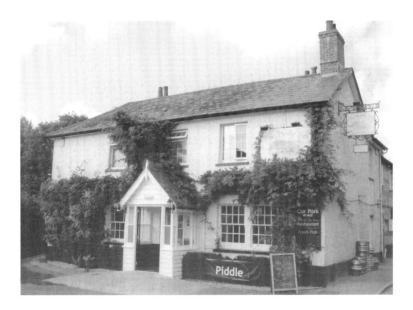

An obvious choice to stock Dorset Piddle Brewery beers, the Piddle Inn is just up the road in Piddletrenthide. In quick succession, the River Piddle valley has four quality watering holes all worth visiting – the Thimble Inn (formerly the New Inn), the European Inn, the Piddle Inn (formerly the Green Dragon) and the Poachers Inn (formerly the New Inn).

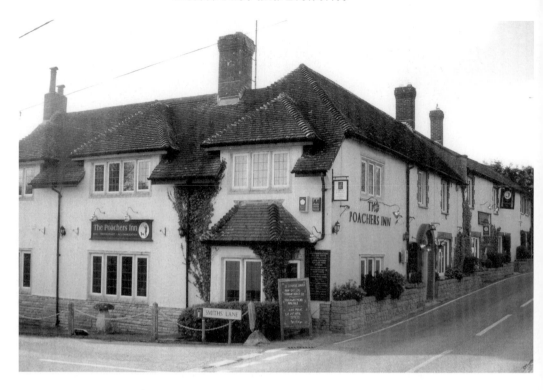

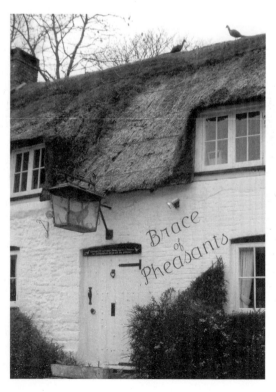

Above: The seventeenth century Poachers Inn at the top of Piddletrenthide has plush letting rooms, a wood-panelled bar, and even a swimming pool. In the eighteenth century it was called the Malt Shovel, and had a malt house, now converted into the restaurant. At the time it was probably a homebrew inn and later on was acquired by current owners Hall & Woodhouse.

Left: The isolated sixteenth century Brace of Pheasants at Plush was originally cottages. Long ago it became the Hankey Arms, named after the local landowner. The inn assumed its current name after the war, during which German POWs put to work on the land were allowed to stop there for refreshments. Rebuilt after a fire in 1979, it remains a gem.

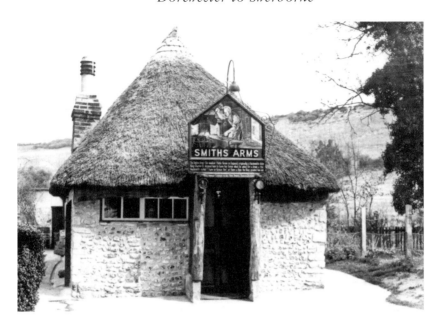

At Godmanstone, the script on the inn sign tells the story, 'The Smiths Arms – The Smallest Public House in England. Originally a blacksmith's shop, King Charles II stopped here to have his horse shod. He asked for a drink and the blacksmith replied "I have no licence, Sire", so there and then the King granted him one.' Currently closed, will it ever open again?

Over a century ago, Sydling St Nicholas had a pub and brewery, but only the Greyhound Inn survives. A superior, well-reviewed country inn, it has been recently refurbished and is worth visiting. Down the road, the St Nicholas Brewery was founded by the Newman family in 1842. It was leased to several brewers in the nineteenth century but in 1905 it was acquired by Groves.

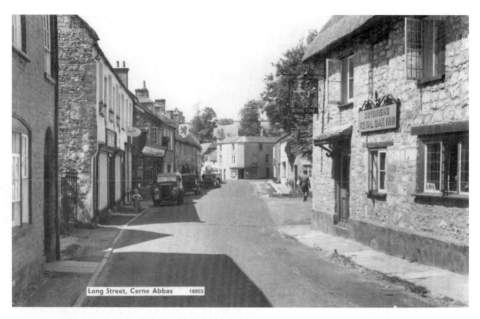

Long Street, Cerne Abbas 18803

During the last 250 years, Cerne Abbas has had fourteen inns. Three survive: The Royal Oak (right), Giant Inn (formerly Red Lion – left) and the New Inn (out of sight). The sixteenth century Royal Oak was partly built of abbey stone and is an excellent traditional pub. The super Giant Inn, rebuilt in Victorian times, still has its appealing Groves windows.

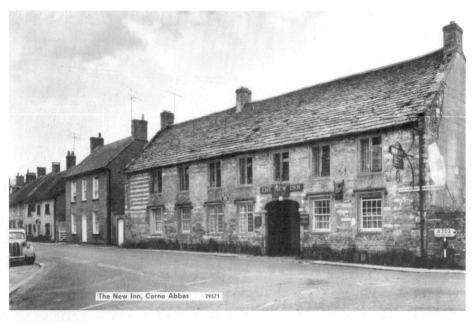

The New Inn, Cerne Abbas 29571

In the Middle Ages, monks from Cerne Abbey enjoyed a reputation for brewing superior ale. At the bottom of Piddle Lane on the site of Chescombe Farm, a brewery was acquired by the Northover family in the mid nineteenth century but brewing ceased in 1883. There were brewpubs too, notably the New Inn (pictured – now a lovely Palmers hostelry) and the Greyhound Inn (closed).

Right: Formerly a Hall & Woodhouse inn called the Royal Oak, the renamed Gaggle of Geese is in the old-world village of Buckland Newton. Several decades ago the landlord started keeping geese. From these humble beginnings a large Charity Poultry Auction is held at the pub twice yearly in May and September, sponsored by Wessex FM and Ringwood Brewery.

Below: Hilda Fripp, daughter of former landlord Jack Mitchell, reminisced about the New Inn at Glanvilles Wootton, 'Beer came in 56 gallon barrels. I remember Baxters (Sherborne) - that was smashing beer. There was never any trouble as people here were so hard-up between the wars'. The New Inn was de-licensed and closed in early October 1955 and is now a private house.

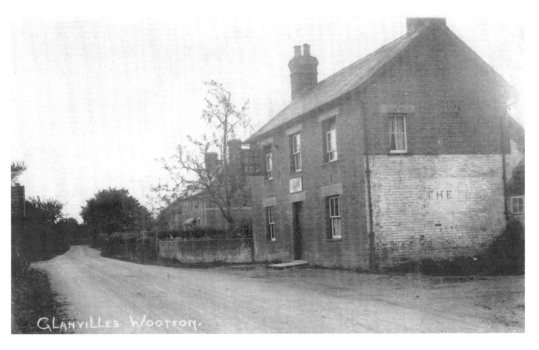

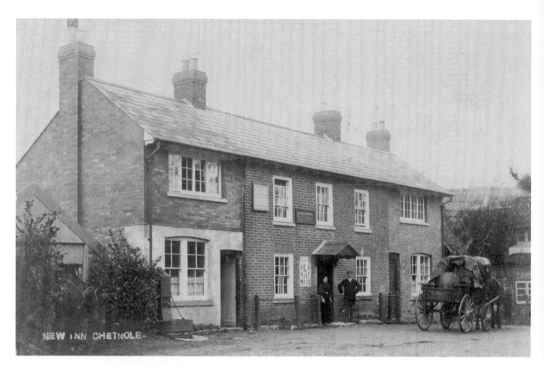

NEW INN CHETNOLE-

Above: Previously the New Inn, the Chetnole Inn has assumed the name of the idyllic rural village it serves. It is 'the kind of pub you could move to a village for'. It runs a beer festival, has up to five ales including three guest beers which focus on west country microbrewers and, to complete the scene, is frequented by Morris dancers.

Left: Details on the Melbury Oak Brewery are sketchy. A few test brews were done locally in the 1990s but mainly the beer was brewed in the north. It travelled poorly but sold at the Rest & Welcome Inn at Melbury Osmond. Roadside east of the A37, the Rest & Welcome Inn stands rejuvenated and has just been confirmed as Thomas Hardy's 'Sheaf of Arrows Inn'.

Since the Railway Inn closed, the seventeenth century White Hart is Yetminster's only pub. It was a homebrew inn for centuries (the brewhouse is now the skittle alley) before the pub was acquired by Baxters of Sherborne in the early twentieth century. The Yetminster and Ryme Intrinseca Junior Folk Dance Display Team, or 'The Yetties' for short, performed here often.

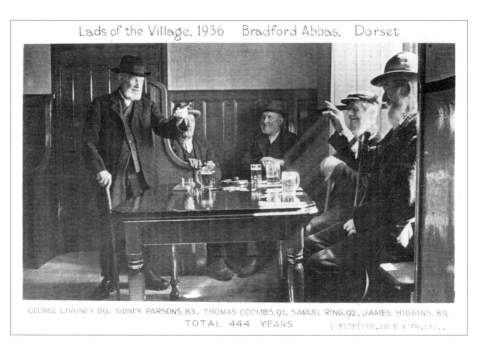

Lads of the Village, 1936 Bradford Abbas, Dorset

GEORGE CHAINEY, 89. SIDNEY PARSONS, 83. THOMAS COOMBS, 91. SAMUEL RING, 92. JAMES HIGGINS, 89.
TOTAL 444 YEARS (ELDRIDGE, POPE & Co, Ltd.,

'Beer and hard work' is the secret to a long life according to the Lads of Bradford Abbas who were photographed at the Rose & Crown. The Lads' combined age aroused so much interest that they appeared in two short Movietone talkie films. Centuries ago, the Rose & Crown was a church house where the monks brewed beer and now is a super, traditional village local.

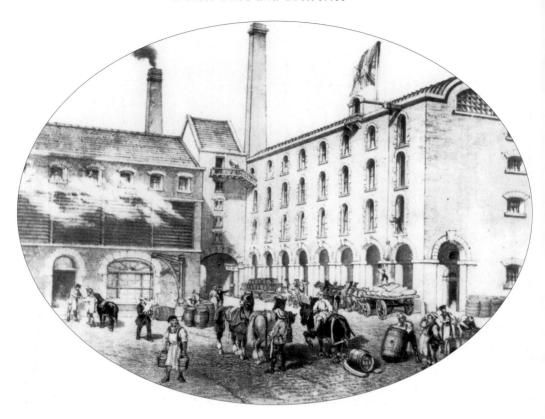

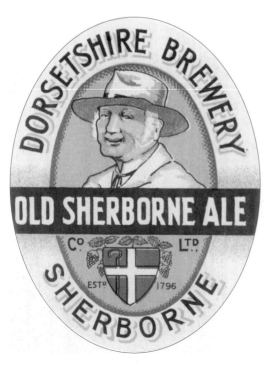

Above: The Dorsetshire Brewery in Long Street, Sherborne was effectively established in 1796, possibly on the site of an earlier concern. In the mid nineteenth century, a smaller brewery in Trendle Street was absorbed into the larger Long Street brewery (pictured). Run during the nineteenth century by a succession of brewers (Thorne, Stephens, Ffookes, Whittle), around 1890 it was bought by William Baxter.

Left: After acquiring several other breweries (in Pilton, Yetminster, Yeovil, Sherborne and Honiton), the Dorsetshire Brewery grew in size. It advertised 'Noted Pale Ales, Beers and Stouts & India Pale Ale – a speciality'. However in 1951 it was taken over by Brutton, Mitchell & Toms (Yeovil) with seventy-eight outlets. The buildings were redeveloped into flats in the 1980s and are now called The Maltings.

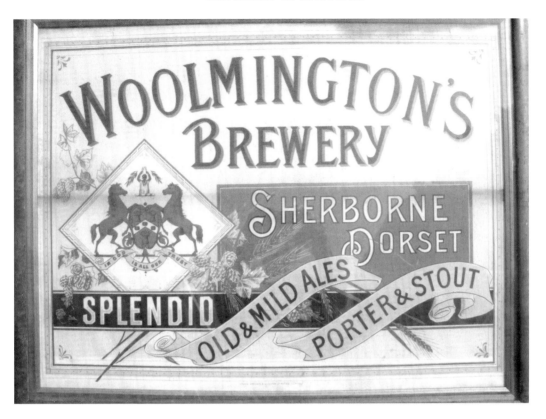

Above: At the top of Cheap Street, another brewery survived into the twentieth century. The aptly named Cheap Street Brewery was founded in the early 1840s and acquired in 1855 by the Woolmington family. They brewed behind the Greyhound (a former homebrew inn – now closed) until 1922 when they were taken over by Eldridge Pope with eight pubs.

Right: In 1999, Woolmington Yard was opened – the old brewery buildings (pictured) were renovated as houses. Down by the station, the old Woolmington Hotel (more recently the Pageant Inn) still has the old stone motif of I. W. (Isaac Woolmington) high on a gable. Also, north of the town centre, off Bristol Road, the Dorsetshire Brewery stone plaque remains on the Mermaid.

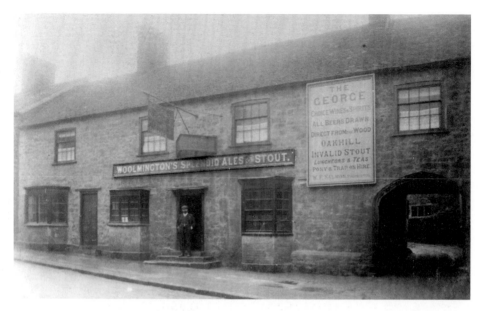

The George Hotel in Higher Cheap Street, Sherborne in the days when it was owned by the Woolmington Brewery. It is Sherborne's oldest surviving pub with a history stretching back to 1406, although the current building is sixteenth century. To the side is a Tudor archway through which Quakers passed quickly on their way to their meeting house at the rear.

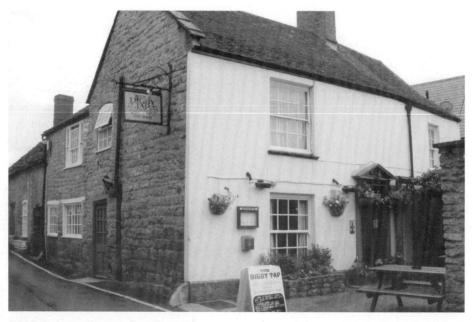

Fifty years ago, there were around twenty inns in Sherborne but today there are about half that. One survivor is the Digby Tap in Cooks Lane. The sixteenth century building was a workhouse but now is an award-winning free house which supports west country ales. The walls are adorned with local brewery memorabilia to remind the visitor of the area's rich brewing heritage.

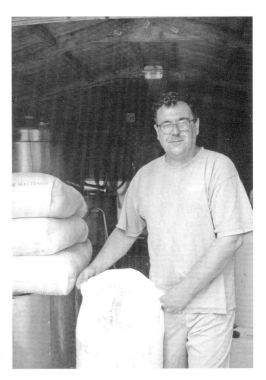

Right: Stephen (pictured) and Martin Walsh set up Sherborne Brewery in 2005 under the direction of Chaz Hobden of the Wessex Brewery. Initially in an old yarn mill, they settled on the present site and have not looked back. Beers such as 257, Cheap Street and Lord Quench are available in their own Doherty's Bar, at beer festivals and in a few selected outlets.

Below: Stephen Walsh is ready to pull another pint of Lord Quench ale in Doherty's Bar. The upstairs bar is named after their grandmother and is intimate and full of character. It is part of the Walsh brothers' main business, the Abbey Friar fish & chip shop in Westbury, now making this area of Sherborne well worth visiting.

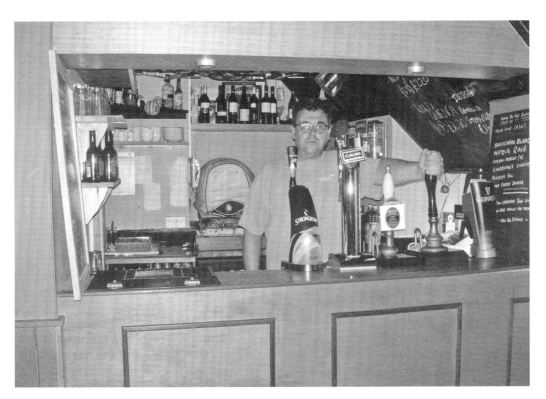

The well-reviewed Rose & Crown at Trent was originally two thatched cottages built to house the builders of the church spire. The cottages were joined together in 1720, forming a farmhouse which served ale until the 1950s. In a wonderful rural setting, long ago beer was brewed at the farmhouse, but now four foaming ales are supplied by Wadworths of Devizes.

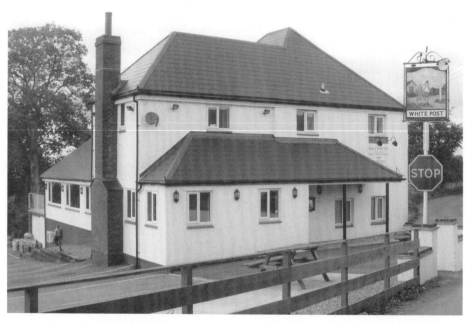

At Rimpton, the county border runs right through the White Post Inn. Going back, Dorset pubs called time at 10.00 pm and Somerset pubs at 10.30 pm. At 10.00 pm, everyone would move across to the Somerset side of the bar for a further half an hour's supping. Even when last orders were standardised, drinkers would still perform the '10 o'clock shuffle' through force of habit.

six

Bridport and Lyme Regis to Beaminster

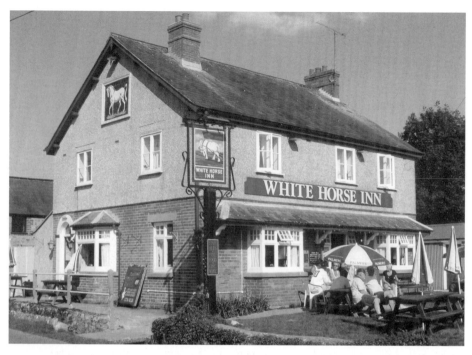

In 1926, fire destroyed the old stone and thatch White Horse at Litton Cheyney. Previously run by the Hawkins family, who were also brewers until the 1860s, the 'new' White Horse is a popular village pub with, unusually, a boule pitch. Nearby, the Gladwin family operated a small brewery from 1792 to the 1890s and produced cider regularly till the 1950s.

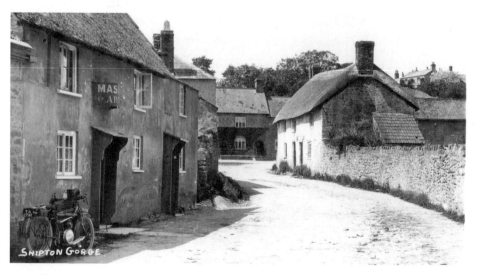

Despite its half-pint size, dances were said to be held at the tiny Masons Arms at Shipton Gorge. The Masons closed and was sold by Palmers in 1968 leaving only the New Inn in Shipton. When this in turn closed, a community action group raised substantial sums and provided free labour to reopen the now superbly run New Inn.

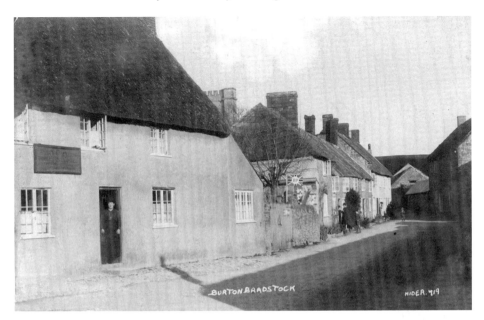

On the corner of the High Street and Mill Street in Burton Bradstock is the super Three Horseshoes. Originally smaller, it has expanded into the old Post Office and reading rooms on the left (out of shot). One of a few Palmers pubs to stock all five ales, there are still benches outside from where generations of Burtonians have watched the world go by.

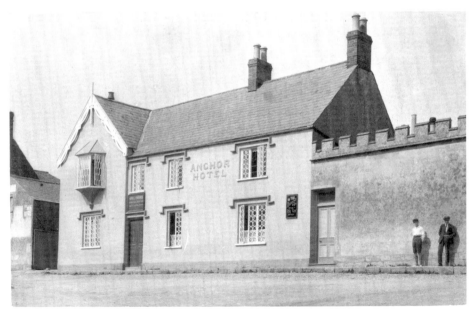

Sadly the Dove, which was in Southover, has closed but thankfully the Anchor survives. The old Burtonians were once described by a local writer as a 'tough, clannish lot, somewhat addicted to cider and fishing'. They would still recognise the exterior of the Anchor, but not the interior as it is now an award-winning gastro pub specialising in seafood.

109

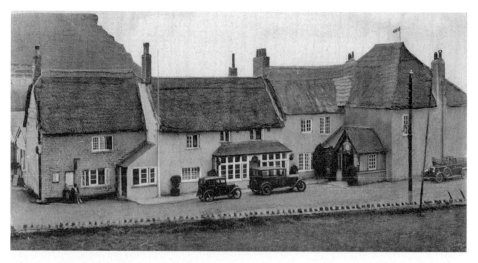

By 1774, an inn was shown on the site of the present Bridport Arms Hotel in West Bay, but it was most likely in a much earlier farmhouse. Situated at the top of the beach, it has been much extended and, along with the West Bay and George Hotels, makes for a very agreeable trio of Palmers establishments.

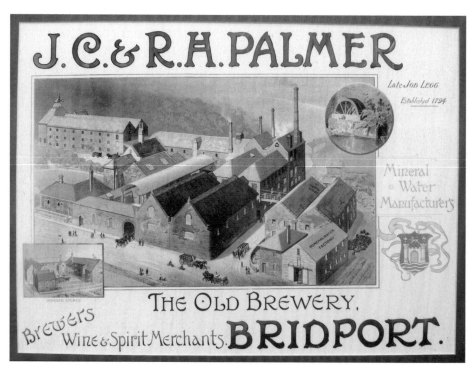

Palmers Brewery has been brewing in Bridport for four generations at the Old Brewery in West Bay Road. Founded in 1794 by the Gundry family, it is the only thatched brewery in the country. Another older brewery premises in Gundry Lane (shown in the vignette bottom left of the print) are used by Palmers as bonded stores.

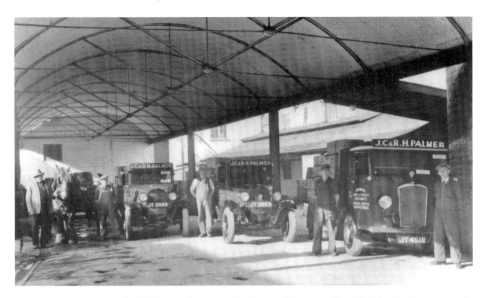

2008 was a good year for Palmers who won the Taste of Dorset – Best Drinks Producer award. The rebranded range of ales has continued to raise thousands for charities such as the RNLI, Dorset & Somerset Air Ambulance and the Chesil Trust.

George Biles worked for Palmers from 1918 until shortly before his death in 1987. In those seventy years, he became a nationally-acclaimed sign writer and would often paint a different picture on each side of the sign. A good example of this is at the New Inn at Stoke Abbott – a super country pub.

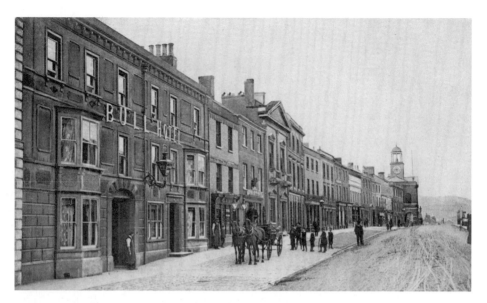

Now painted in more muted colours than before, the Bull Hotel in East Street is styled as a 'boutique' hotel with a café bar atmosphere. It was Bridport's top coaching inn, used by the Royal Mail and a passenger coach named Celerity. Beer was brewed at the Bull for over 200 years, up to the 1920s, but that was a different age.

Most worthy of its CAMRA *Good Beer Guide* inclusions is the Tiger Inn, just off East Street in Barrack Street. The ex-Devenish Victorian alehouse is now a superb establishment with an ever-changing selection of ales from countrywide breweries. The Tiger and other good pubs such as the Ropemakers and the Woodman Inn ensure Bridport is a prime venue.

Right: Fifty years ago, Bridport was known to drinkers as the 'deck of cards town' as it had fifty-two drinking establishments in or around town. Now there are about half that number. One that closed was the Star Hotel in West Street, (bombed in the war and one of only four Devenish houses in Bridport). It is now The Dairy Maid shop and Chicken Land takeaway.

Below: In North Allington only the Oddfellows Arms survives, after the Kings Arms and Boot Inn closed in recent years. On the map as a cottage in 1770, it now styles itself as a 'poseur-free, working men's local'. The pub sign was painted by George Biles and refers to a Friendly Society where members could pay a penny a week against future mishaps.

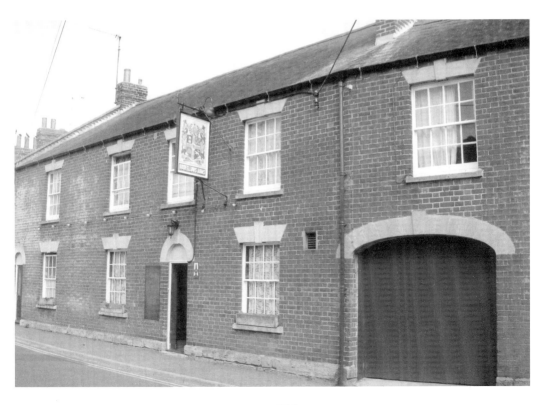

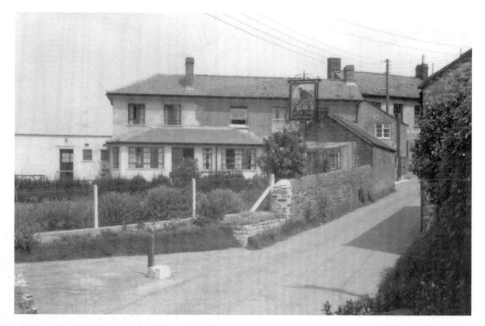

In 1922, the seaside village of Eype was crowned the 'quietest resort in the country' by the *Daily Express*. The New Inn reflects this tranquillity. It was previously in the news in 1881 when the balloon 'Saladin' slipped its line. One injured passenger, Mr Agg-Gardner, was taken to the New Inn, while another, Mr Powell MP was never seen again.

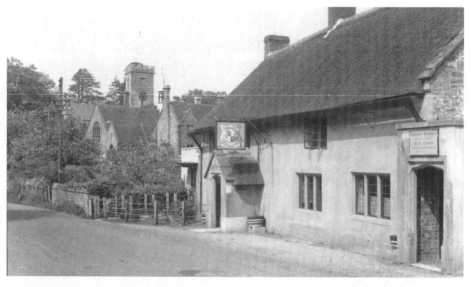

The Ilchester Arms at Symondsbury dates from the sixteenth century and is a tremendously character-filled, traditional country inn with beams originally from keels of ships. Former landlords have also been bakers, butchers, coal merchants or brewers. The inn and brew-house were acquired by John Groves around 1900 and are now owned by Palmers. The renowned Symondsbury Mummers give performances at the pub.

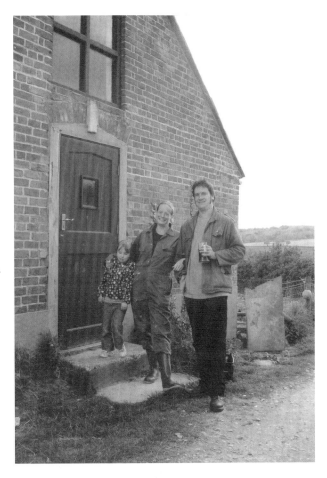

Right: Zoe, Becky and John Whinnerah stand outside the Art Brew brewery in North Chideock. Having had phenomenal success in Bath with their award-winning pub, the Royal Oak, they started Art Brew in Summer 2008. Things progressed well until a French delivery driver left nearly 200 new casks at the side of the busy A35 in Chideock, 2 miles down farm tracks from the brewery!

Below: Art Brew's first beer was called 2 am, as with only minimal experience it took all day and into the small hours to complete the brew. Having served hundreds of different beers through the pub, the aim is to experiment with flavours, for example i Beer – a golden vanilla beer, and Spanked Monkey – root ginger & chilli are added to the innocent Monkey IPA.

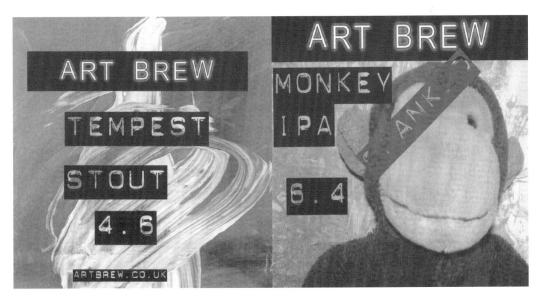

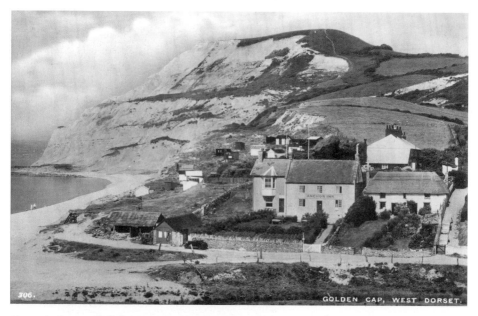

Centre is the wonderfully positioned Anchor Inn at Seatown, dominated by the brooding mass of Golden Cap – the highest cliff on the South Coast. The Anchor had connections with smuggling for centuries and probably the last major smuggling run in the area occurred off Seatown in 1882. Today, carrom can be played while Palmers ales are supped.

In living memory, Morcombelake had two Palmers pubs. The recently closed Ship (pictured right) is now the Artwave West Gallery. The Sun, which closed in 1965, was opposite the Moores Biscuit Bakery – famous for the Dorset Knob. Strangely, the only pub called the Dorset Knob is right at the other side of Dorset in Parkstone.

At the bottom of the hill in Charmouth, the George is a superior seventeenth century coaching inn which retains many original features. On its journey to becoming a free house it passed through the hands of many breweries – Crewkerne United Breweries, Hancocks (Wiveliscombe), Ushers (Trowbridge) and Watneys (London). It is well worth visiting, especially as heavy traffic now takes the bypass.

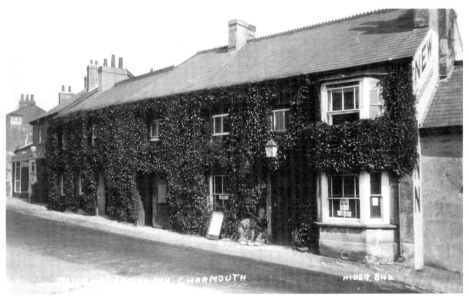

Along The Street in Charmouth, fifty years ago there were six drinking establishments. Now only three remain. Starting from the top were the New Inn (pictured – closed), the Royal Oak (open - a lively traditional Palmers pub), the Coach & Horses Hotel (closed), the Star (closed), the Queens Armes (open – now called Abbotts House Hotel) and the George.

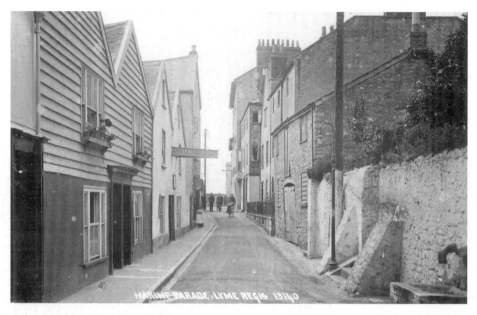

At the Cobb end of Marine Parade in Lyme Regis, the Royal Standard is on the left of this ancient lane. Built 400 years ago using ships' timbers, it now serves well-kept Palmers beers. As does the much newer Cobb Arms around the corner. Opened in 1937, it is light and airy with super views of the harbour.

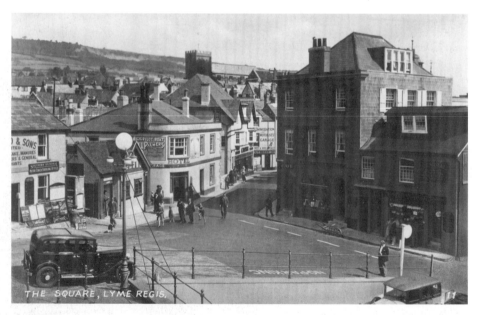

The Pilot Boat (centre) in Bridge Street has been a Palmers pub for over a century. After HMS *Formidable* was sunk on 1 January 1915, the landlord's collie called Lassie licked the face of Able Seaman John Cowan, presumed drowned, and revived him. This story, it is claimed, was the inspiration for the *Lassie* tales written by Eric Knight.

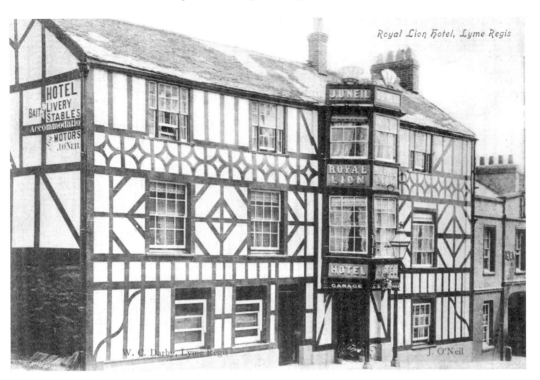

Royal Lion Hotel, Lyme Regis

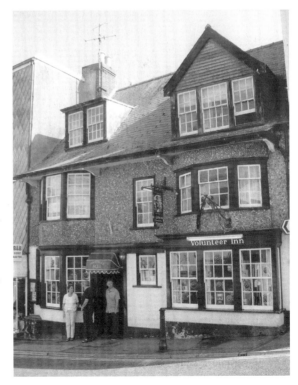

Above: The mock beams painted on the Royal Lion Hotel in the 1900s were soon painted over. Next door, the New Inn, an old brewpub, was later absorbed into the hotel. Other old brewpubs include the Three Cups, Golden Hart and London Inn (now a B&B). Elsewhere in town Gundry's Brewery burnt down in 1844 and Thomas Trafford's Lyme Regis Brewery closed in the 1860s.

Right: In 1909 the Mayor and police tried to close the Volunteer at the top of Broad Street, saying there were too many pubs in Lyme. Back then, the landlord Edward Tristan's defence was that his clientele differed from that of the hotels and he served many passing cyclists. This is mostly true today, but there are fewer cyclists to sample the changing range of local ales.

At Maiden Newton, the Brewery pub was renamed the Chalk & Cheese. There is still evidence of the old Maiden Newton Brewery to the right of this lively village local. In 1848, the brewer was H Cox and when Reynolds Bros & Heathorn of Weymouth acquired the brewery, Robert Rixon was in charge. Closed by Groves in 1894, Rixon then moved to Weymouth as head brewer.

The wonderful, characterful seventeenth century White Horse Inn at Maiden Newton was demolished by Devenish in 1898 despite protestations from villagers and also from Thomas Hardy. He described the building as being in a dreadful state and, when it was pulled down, the thatch was six or seven layers deep. The White Horse was rebuilt and stands today sadly converted to flats.

The Fox & Hounds at Cattistock was voted 'Dorset's Best Locals' Pub' at the 2009 Taste of Dorset Awards, a prize richly deserved by Scott and Liz Flight. Now owned by Palmers, the Parrott family brewed at this magnificent hostelry in the nineteenth century before it was bought by Groves. The village of Cattistock is also home to the Dorset Knob throwing championships.

At Mangerton Mill, an 1875 inventory showed a brew-house, cellars, cider house and hop room. The Mangerton Brewery had its own water wheel powered by an underground pipe from the mill pond. William Garland was miller from 1871-1899 and ran the brewery until 1896 when it was acquired by Palmers with two pubs (including the excellent Marquis of Lorne at Nettlecombe).

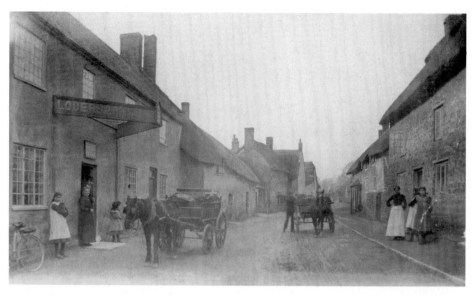

When the Farmers Arms in Loders closed in 1973, one Palmers house was left in the village – the Loders Arms. It is still a super unpretentious country inn with well-kept beers. Away from the village, the Travellers Rest on the main A35 is now a caravan site. Long ago, ale was brewed here and the old equipment remained until the 1980s.

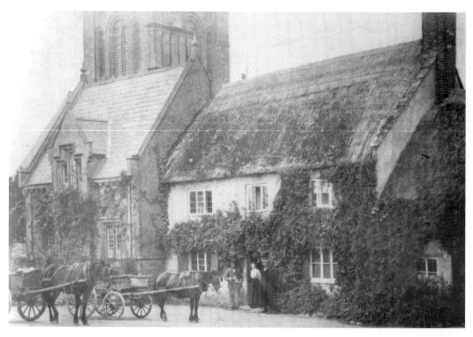

The 300 year old Half Moon Inn at Melplash is at the heart of the community, with the church and old schoolhouse to the left and the cricket field to the right. Halfway through its history, two farmers quarrelled in the inn as to who was the best ploughman. The ensuing ploughing contest has turned into the annual Melplash Show.

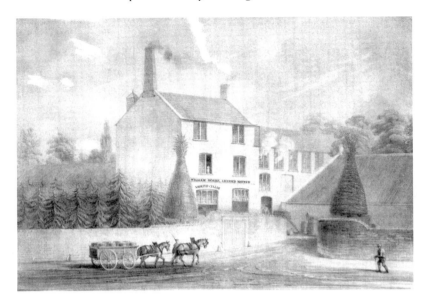

William Hoare founded the Knapp Brewery in Netherbury in 1846 and sold it to the Hine family ten years later. Henry Pulman acquired the brewery in 1867 and sold it to Job Legg of Bridport in 1876 with 5 pubs (including the New Inn and Star Inn at Netherbury). Demolished in 1938, Palmers used the stone to rebuild the Toll House Hotel in Bridport.

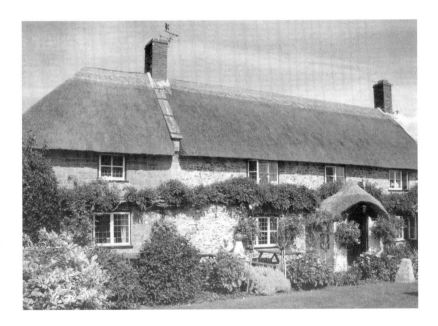

Pilgrims and monks who required tonsuring stopped at Shave Cross before they visited the shrine of St Wite at Whitchurch Canonicorum. Hence the name of the classic, multi-award winning Shave Cross Inn. A Dorset gem, the inn was resurrected by Roy Warburton and his wife Mel in 2003 and unusually serves 'British authentic Caribbean cuisine', and great beer.

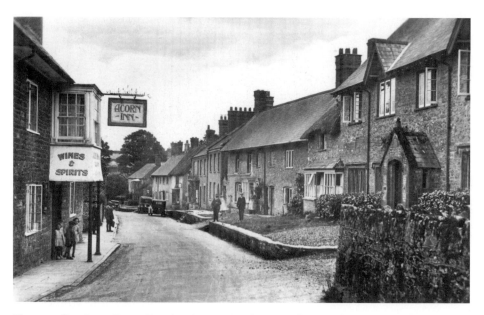

The appealing Acorn Inn at Evershot is a sensitively restored sixteenth century coaching inn. Many moons ago, ale was brewed here and at the nearby New Inn and Royal Oak. Now, ever-changing beers are available in the plush lounge bar or in the 'Village Bar' to the rear, where the results of yard of ale quaffing are chalked on a board.

Despite its ferocious name, the Tigers Head Inn at Rampisham was worth seeking out, although the nineteenth century village Bobby reported that the inn was the source of much drunkenness and disorderly conduct. A traditional, unspoilt free house with a choice of up to five ales, it sadly closed a decade ago leaving Rampisham without a pub.

The Red Lion in Beaminster dates back to 1618 but was rebuilt in 1892 and recently modernised by Palmers. It had a brewhouse and a number of different brewers over three centuries. Other homebrew inns were the White Hart, New Inn, Star, Swan and Eight Bells (which was called the Five Bells until 1765 when the number of church bells increased to eight).

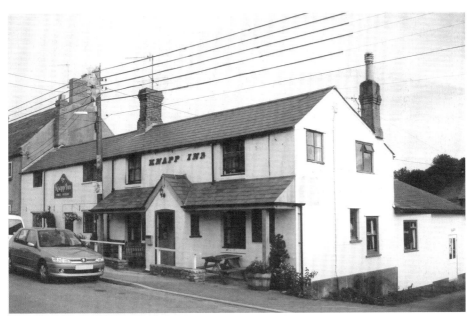

Away from the centre of Beaminster in Clay Lane is the Knapp Inn, a well-run free house which is popular with locals. It appeared as a pub in Victorian times and is a worthy entry in CAMRA's *Good Beer Guide*. The guest beers are usually seasonal local ales and, for Jack Daniels fans, there are seven different types to try.

Occupying a wonderful position at a break in the downs overlooking the Blackdown and Quantock Hills, the ancient Winyards Gap Inn has been rebuilt several times and recently refurbished. The inn aroused national interest in the 'Gypsy's Alibi' case of 1753. Mary Squires had been sentenced to hang but was given a free pardon after witnesses at the inn gave her an alibi.

At South Perrott, the Bakers Arms (left) sadly closed long ago and is now holiday lets. Behind the Post Office (right – also closed) the Coach & Horses Inn survives. A country local selling Exmoor Ales, it has an iron-studded Tudor door preserved in the porch – a relic from when Parliamentarians tore down Mohun Castle on learning that Charles I had been sheltered there.

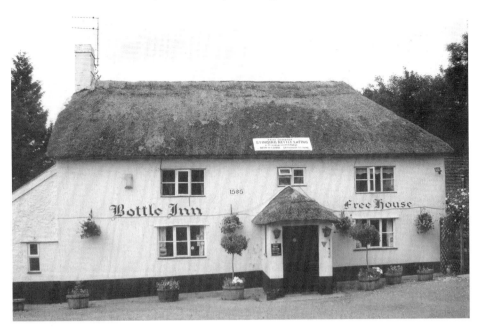

Advertising that an inn sold bottled ales was all the rage 200 years ago and the Bottle Inn at Marshwood is living proof of this. The World Nettle Eating Championship is held here annually and as at the Half Moon at Melplash, a competition came about following a cider-fuelled challenge. Current black-tongued champs Mike Hobbs and Mel Lang are both from Dorset.

The Royal Oak at Thorncombe was closed by Ushers in 1958. Up the road, the Golden Lion closed in the 1960s and down the road the Old Crown closed in 1939. Nearby the Golden Fleece at Holditch shut in 1971 and the Rose & Crown at Birdsmoor Gate in the late 1970's. The message has to be: VISIT YOUR LOCAL.

Bibliography

Towns and Villages of England - Beaminster, Gerald Gosling (Alan Sutton Publishing)
Blandford Inns, Victor J Adams (Blandford Forum Museum Trust)
Cerne Abbas, A O Gibbons, Longmans (Dorchester) Ltd
A Peep at Eype – The Story of a Dorset Village in Postcards, Paul Atterbury (The Eype Historical Group)
Hall & Woodhouse 1777-1977, Hurford James (Henry Melland, London)
Images of England – Around Bridport and Lyme Regis, Gerald Gosling and Les Berry (Tempus Publishing Ltd)
Britain in Old Photographs – Lyme Regis Past & Present, Jo Draper (Sutton Publishing)
Maiden Newton & Frome Vauchurch, a short guide and walk, Judith Stinton
Milton Abbas, Dorset, an illustrated guide by C H R Fookes
Palmers, The Story of a Dorset Brewer, Tim Heald (Palmers Brewery)
A Pint of Good Poole Ale, Poole's Inns, Taverns and Breweries, Andrew Hawkes (Poole Historical Trust)
Portland An Illustrated History, Stuart Morris (The Dovecote Press)
Swanage Encyclopaedic Guide, Rodney Legg (Dorset Publishing Company)
Swanage Past, David Lewer & Dennis Smale (Phillimore & Co Ltd)
Wareham Gateway to Purbeck, Terence Davies (Dorset Publishing Company)
The West Bay Book, John Eastwood (Winterbourne Publications)
A History of English Ale & Beer, H A Monckton (The Bodley Head)
Pub Games of England, Timothy Finn (Queen Anne Press Limited)
Dorset Inns, Harry Ashley (Countryside Books)
Pubs and the Past, Hostelry and History in Dorset, Ivan Mason (self published)
Pub Strolls in Dorset, Anne-Marie Edwards (Countryside Books)
Pub Walks in Dorset, Forty Circular Walks Around Dorset Inns, Mike Power (Power Publications)
Forty More Pub Walks in Dorset, Forty Circular Walks Around Dorset Inns, Mike Power (Power Publications)
Discover Dorset The Industrial Past, Peter Stanier (The Dovecote Press)
Old Dorset Inns Dorset, Donald Stuart (self published)
Old Dorset Brewers, Jimmy Young (Better Pubs Ltd)
History of Better Pubs in Dorset, Jimmy Young (Better Pubs Ltd)
Ed's Pint East Dorset CAMRA's Newsletter
Drinking Inn East Dorset, CAMRA publication
Real Ale in Hardy Country, CAMRA publication
Good Beer Guide, various years, CAMRA publication
A Century of British Brewers – Plus, Brewery History Society publication